Royal College of Physicians

Prolonged disorders of consciousness
National clinical guidelines

Report of a working party 2013

Endorsed by:

Association of British Neurologists
Association for Palliative Medicine
British Society of Rehabilitation Medicine
Chartered Society of Physiotherapy
College of Occupational Therapists
Society of British Neurological Surgeons
Society for Research in Rehabilitation

The Royal College of Physicians

The Royal College of Physicians plays a leading role in the delivery of high-quality patient care by setting standards of medical practice and promoting clinical excellence. We provide physicians in over 30 medical specialties with education, training and support throughout their careers. As an independent charity representing more than 29,000 fellows and members worldwide, we advise and work with government, patients, allied healthcare professionals and the public to improve health and healthcare.

Citation for this document: Royal College of Physicians. *Prolonged disorders of consciousness: National clinical guidelines.* London, RCP, 2013.

Review date: 2018

Royal College of Physicians
11 St Andrews Place
Regent's Park
London NW1 4LE

www.rcplondon.ac.uk
Registered Charity No 210508

Typeset by Cambrian Typesetters, Camberley, Surrey
Printed in Great Britain by Charlesworth Press, Wakefield, West Yorkshire

Contents

Members of the working party

Core Executive and Editorial Group (CEEG)	Representation
Professor Lynne Turner-Stokes (chair) Consultant in rehabilitation medicine, Northwick Park Hospital; Herbert Dunhill Professor of Rehabilitation, King's College London	British Society of Rehabilitation Medicine
Professor Derick Wade (co-chair) Consultant in rehabilitation medicine, Oxford Centre for Enablement; Professor of neurological rehabilitation	Association of British Neurologists; The Society for Research in Rehabilitation
Dr Diane Playford (co-chair) Consultant in rehabilitation medicine, Institute of Neurology, Queen Square; Reader in neurological rehabilitation, University College London	Association of British Neurologists
Professor Jenny Kitzinger (co-ordinator for service user input) Professor of communications research, Cardiff University; Health and Welfare Deputy and sister of a patient who was previously in a PDOC	

Working party members – Guideline Development Group	
Dr Judith Allanson Consultant in rehabilitation medicine, Addenbrooke's Hospital, Cambridge	British Society of Rehabilitation Medicine
Yogi Amin Solicitor; partner in Public Law Department, Irwin Mitchell	
Dr Derar Badwan Consultant in rehabilitation medicine, Royal Leamington Spa Rehabilitation Hospital	
Kellie Blane Associate director of specialised commissioning, North East Sector, London	
Dr Patrick Cadigan (ex-officio) Registrar	Royal College of Physicians
Valerie Caless RCP Patient and Carer Network (PCN) member; PCN member on the RCP Committee for Ethical Issues in Medicine (CEIM)	Royal College of Physicians
Dr Maggie Campbell Long Term Neurological Conditions (LTNC) Strategy Manager, Sheffield PCT	Chartered Society of Physiotherapy

Dr Martin Coleman⁺
Clinical physiologist, University of Cambridge

Jakki Cowley Delivery manager, Action for Advocacy, London (until 28 March 2013)	Action for Advocacy
Dr Charles Daniels Consultant in palliative medicine, St Luke's Hospice	Association for Palliative Medicine
Dr Mark Delargy Consultant in rehabilitation medicine, National Rehabilitation Hospital, Co Dublin	
Bridget Dolan Barrister, 3, Serjeants' Inn, London	
Dr Karen Elliott Occupational therapist, University of East Anglia	College of Occupational Therapists
Professor Rob George Professor of palliative care, King's College London; consultant in palliative care, Guy's and St Thomas' NHS Foundation Trust, London	Association for Palliative Medicine; The National Council for Palliative Care; Royal College of Physicians CEIM
Helen Gill-Thwaites MBE Occupational therapist, Royal Hospital for Neuro-disability, Putney	
Di Halliwell Head of continuing care, Central London Community Health Care. Hammersmith & Fulham	
Professor Tom McMillan Professor of clinical neuropsychology, Institute of Health and Wellbeing, University of Glasgow	The British Psychological Society
Professor John Pickard Professor of neurosurgery, Department of Clinical Neurosciences, University of Cambridge	Society of British Neurological Surgeons
Dr Neil Roberts General practitioner, Sawbridgeworth, Hertfordshire	
Professor John Saunders Consultant physician, Nevill Hall Hospital; chair, RCP Committee on Ethical Issues in Medicine (CEIM)	Royal College of Physicians CEIM
Keith Sephton Database manager, UK Rehabilitation Outcomes Collaborative	
Wendy Stuttle Physiotherapist, Ramsay Healthcare UK	
Sir Richard Thompson (ex-officio) President, Royal College of Physicians	Royal College of Physicians
Dr Krystyna Walton Consultant in neuro-rehabilitation, Salford Royal NHS Foundation Trust	British Society of Rehabilitation Medicine

⁺ Sadly deceased 17 December 2011.

Carolyn Young
Specialised commissioner, East of England Specialised Commissioning Group

Support to the GDG provided by:

Linda Cuthbertson Press and PR manager	Royal College of Physicians
Simon Land Head of consultation and committee services	Royal College of Physicians
Natalie Campbell Secretary, King's College London	

The GDG was supported by two subgroups working in specific areas with additional co-opted expertise.

Subgroup 1: End-of-life and palliative care

GDG members	**Professor Rob George** **Dr Charles Daniels** **Professor Lynne Turner-Stokes**
Co-opted members	**Dr Penny McNamara** Consultant in palliative medicine, Bedford Hospital **Dr Rowan Burnstein** Director of neurocritical care, Addenbrooke's Hospital **Dr Suzanne Kite** Lead clinician for palliative care, Leeds Teaching Hospitals NHS Trust **Dr Sheila Popert** Consultant in palliative medicine, Trinity Hospice, London **Dr Emma Hall** Consultant in palliative medicine, St Christopher's Hospice **Dr Sarah Galbraith** Consultant in palliative medicine, Addenbrooke's Hospital **Dr Andrew Castello-Cortes** Consultant in anaesthesia and intensive Care, Northwick Park Hospital

Subgroup 2: Ethics and medico-legal aspects

GDG Members	**Professor Rob George** **Professor John Saunders** **Yogi Amin** **Bridget Dolan** **Professor Jenny Kitzinger** **Jakki Cowley** **Professor Derick Wade** **Professor Lynne Turner-Stokes**

Advisory contributions from clinicians at the Royal Hospital for Neurodisability, Putney

Specific aspects of communication and assessment	**Sarah Haynes** Head of speech and language therapy **Amy Pundole** Clinical lead speech and language therapist **Dr Sal Connolly** Consultant clinical neuropsychologist

Guideline Development Group

The multidisciplinary GDG included representation from patients/users and a wide range of stakeholders and professionals involved in the management of patients with PDOC.

GDG membership was selected to provide a broad range of views and opinion, especially with respect to the more challenging issues, such as ethics and end-of-life decisions. These were confirmed by a

questionnaire at baseline to ascertain members' beliefs, attitudes and practice in relation to key issues that would be addressed in the guidelines, such as the withdrawal of life-sustaining treatment, and the use of diagnostic tools etc.

The GDG met on three occasions. The RCP provided a meeting room and refreshments, but GDG members were expected to fund their own time and travel expenses, or to seek funding from their affiliated organisations.

Conflicts of interest

Any conflicts of interest were fully declared and are available from the authors. A Declaration of Interests form was completed by all GDG members prior to the first meeting. Members were reminded at each of the subsequent working party meetings of the need to disclose any potential new conflicts of interest as these arose.

In summary, none of the GDG members had any personal financial interest in the recommendations put forward in this guidance.
- None of the GDG members were affiliated with any pro-life or pro-euthanasia group.
- Two members of the group, Helen Gill-Thwaites and Karen Elliott, were the originators of the SMART and four members (Derar Badwan, Helen Gill-Thwaites, Lynne Turner-Stokes and Derick Wade) regularly act as expert witnesses in applications to the Court relating to withdrawal of clinically assisted nutrition and hydration.
- Two members (Yogi Amin and Bridget Dolan) regularly act as lawyers in applications to the Court for withdrawal of clinically assisted nutrition and hydration.
- Many of the GDG members are working within NHS or independent provider settings to offer services for patients in PDOC.
- Some GDG members are actively involved in research in this area.
- Some GDG members have personal experience of living with or caring for a person in VS or MCS.
- All GDG members are primarily concerned with improving the quality of care offered to patients with PDOC and their families.

Acknowledgements

The GDG would like to thank all of the patients, their families and the multidisciplinary teams whose collective experience has gone into the formulation of these clinical guidelines.

On behalf of the Royal College of Physicians (RCP), and the other organisations represented, we would like to thank the GDG and subgroup members who gave freely of their time to contribute to the substantial work involved in the development of these guidelines.

Special acknowledgement

The GDG would like to acknowledge the particular contribution of Martin Coleman, who sadly lost his life in a climbing accident before these guidelines were completed. His effective, well-considered and timely input set an example for us all to follow.

Working party remit

The objectives of this working party were to update and clarify the 2003 Royal College of Physicians (RCP) report, *The vegetative state*,[1] and to achieve a more consistent approach to diagnosis and management of patients with prolonged disorders of consciousness (PDOC), including vegetative (VS) and minimally conscious states (MCS).

The guideline covers:

1 Definitions and criteria for diagnosis of vegetative and minimally conscious states
2 Assessment, diagnosis and monitoring
3 The care pathway from acute to longer-term management
4 Ethical and medico-legal issues
5 End-of-life decisions and care
6 Service organisation and commissioning

The guideline also makes recommendations for development of a register and an agreed minimum dataset to gather systematic longitudinal data in order to identify factors that predict outcome and emergence from a minimally conscious state.

Methodology

A summary of the methodology of guideline development according to the AGREE guidelines is given in Table 0.1.

The evidence typology developed for the National Service Framework for Long Term Conditions was used to grade the evidence and formulate the recommendations.[2]

Further details of guideline methodology are given in Appendix 1.

Administration

Guideline development was led through the Royal College of Physicians (RCP) and the British Society of Rehabilitation Medicine (BSRM).
- The Guideline Development Group (GDG) was administered as a working party through the Professional Affairs Department of the RCP.
- The guideline development process was overseen by the RCP Clinical Standards Department.
- Iterative review in the draft stages of the document was provided through the BSRM Research and Clinical Standards Committee, and the Concise Guidance Steering Group within the RCP.

Drafting of the report

A Core Executive and Editorial Group (CEEG) was responsible for progressing the draft guidelines in between meetings.

The CEEG consisted of the three subgroup chairs and Professor Jenny Kitzinger, as lead for patient and family representation.

Professor Lynne Turner-Stokes, as chair of the GDG, was responsible for the overall drafting of the final guideline document.

Guideline development process

The guidelines have been developed in accordance with the principles laid down by the AGREE collaboration (Appraisal of Guidelines for Research and Evaluation).[3]

Table 0.1. Summary of methodology for the guidelines development according to the AGREE guidelines.

Scope and purpose:

Overall objective of the guidelines	To update and clarify the RCP guidance on vegetative states and to achieve a more consistent approach to diagnosis and management of patients with prolonged disorders of consciousness (PDOC), including vegetative (VS) and minimally conscious states (MCS).
The patient group covered	Patients with PDOC, including VS and MCS.
Target audience	Clinicians, commissioners and providers of services for people in PDOC following profound brain injury.
Clinical areas covered	1 Definitions and terminology of PDOC 2 Techniques for assessment, diagnosis and review 3 Care pathways from acute to long-term management 4 Ethical and medico-legal issues, including the Mental Capacity Act 2005, and practical aspects of *best interests* decision-making 5 End-of-life decision-making and terminal/palliative care 6 Service organisation and commissioning.

Stakeholder involvement:

The Guideline Development Group (GDG)	A multidisciplinary group representing physicians working with patients with PDOC; allied health professionals; commissioners; advocacy services; legal professionals and patient/family representatives.
Consultation	The penultimate draft of the guidelines was circulated widely among stakeholder organisations. Comments received were addressed in the final document.
Funding	Limited funding was provided by the BSRM. Central administrative support and the cost of meetings was provided by the RCP.
Editorial independence	All members of the GDG declared any conflicts of interest.

Rigour of development:

Evidence gathering	See Appendix 1.
Review process	The evidence from the literature reviews was evaluated by members of the GDG.
Links between evidence and recommendations	The NSF typology was used to formulate grades of recommendation (see Appendix 1 for details).
Piloting and peer review	In the course of development, draft guidelines were reviewed by the BSRM Research and Clinical Standards Committee and by the RCP Concise Guidance Steering Group. The final draft was approved by the BSRM Executive Committee, the RCP Clinical Standards Committee and the RCP Council.

Applicability and implementation:

Tools for application	A number of electronic annex documents are included which provide more specific operational advice about implementation of the recommendation; tools and checklists; and access to other useful functional measures for patients emerging from a PDOC. The annexes are available at www.rcplondon.ac.uk/pdoc.
Plans for update	The guidelines will be reviewed in 2018.

Preface

Patients who remain in a vegetative or minimally conscious state following profound brain injury present a complex array of clinical and ethical challenges to those who care for them. Diagnosis is often difficult and may change over time as patients recover awareness, requiring repeated skilled assessment by clinicians with specific experience in this area. Furthermore, by definition, these individuals lack the mental capacity to make decisions regarding their own care and treatment, so that these have to be made for them on the basis of their best interests.

Exactly where those interests lie will vary from patient to patient. There are widely differing views, both amongst clinicians and the general public, about issues such as where patients are cared for; the appropriate use of life-sustaining treatments; and management at the end of life. Family members and the treating team may sometimes come into conflict in their respective efforts to do what they believe to be right for the patient. Usually these conflicts can be resolved through open and frank discussion, but in some instances they may require judgement from the Court.

These guidelines update the previous Royal College of Physicians working party report, *The vegetative state*, to encompass minimally conscious states and also the more recent clinical and legal developments including the principles laid down in the Mental Capacity Act 2005. They do not seek in any sense to challenge existing law, but attempt to lay out for clinicians, service providers and commissioners what constitutes best practice within the existing legal framework, to enable them to fulfil their various responsibilities to the patient and their family.

The guidelines address some highly emotive and topical areas in which there is currently a dearth of formal research-based evidence to guide practice. The Guideline Development Group was deliberately chosen to represent a wide range of opinion. Some areas provoked rigorous and prolonged discussion, but we have endeavoured to provide a balanced view, based on the best evidence available at the current time.

Further systematic longitudinal data collection is urgently required in this area and the group has recommended the development of a national register and dataset to facilitate this. This recommendation is strongly endorsed by the RCP's Council.

In this rapidly changing field the recommendations are likely to need updating as new evidence emerges and as international consensus develops. In the meantime, we have aimed to provide a practical and useful source of advice for clinicians who work with this complex group of patients.

December 2013

Professor Lynne Turner-Stokes
Professor Derick Wade
Dr Diane Playford
Co-chairs of the Guideline Development Group

Executive summary

These guidelines update the 2003 RCP working party report, *The vegetative state*,[3] and aim to achieve a more consistent approach to diagnosis and management of patients with prolonged disorders of consciousness (PDOC), including vegetative (VS) and minimally conscious states (MCS).

The guidelines are prepared in six sections covering the following areas:

Section 1 provides definitions and criteria for diagnosis of vegetative and minimally conscious states.
- It examines the factors that affect prognosis for recovery and sets out the conditions under which VS and MCS may be classified as 'continuing' or 'permanent'.
- It also describes operational parameters for demonstrating reliable and consistent responses to indicate emergence from MCS into full consciousness.

Section 2 describes the clinical assessment, diagnosis and monitoring of patients with PDOC.
- It recommends the use of structured clinical assessment tools alongside detailed clinical assessment, presenting three key instruments along with their various advantages and disadvantages.
- It describes the use of these tools for long-term evaluation and monitoring, laying out key time points for assessment and diagnosis to inform clinical and '*best interests*' decision-making.
- It also explores the role of imaging and electrophysiology, and reviews the evidence for interventional programmes, including medication and sensory stimulation.
- Finally it offers some practical techniques for screening for symptoms, such as pain and depression.

Section 3 describes the care pathway from acute to longer-term management.
- It sets out the general principles and describes the stages of care from management in the acute setting, through specialist neurorehabilitation, to slow-stream placement and ultimately long-term care.
- It also provides guidance on providing support for families as they confront the challenges of catastrophic brain injury.

Section 4 addresses ethical and medico-legal issues.
- It describes the Mental Capacity Act 2005 and lays out the provisions of the Act to support decision-making for persons who lack capacity – including the roles of a Health and Welfare Lasting Power of Attorney, a Court-appointed Welfare Deputy and an Independent Mental Capacity Advocate (IMCA), as well as those of the family and treating team.
- It describes the process required to document lack of capacity and to establish the patient's best interests, and to obtain information about their likely wishes – also setting out practical arrangements for '*best interests*' decision-making meetings.

- It goes on to consider the ethical challenges of VS and MCS, including decisions regarding life-sustaining treatments.
- It highlights the responsibility of clinicians to comply with any Advance Decision to Refuse Treatment (ADRT) that is valid and applicable.
- It also addresses the circumstances in which it may be appropriate to consider application to the Court of Protection for withdrawal of clinically assisted nutrition and hydration (CANH).

Section 5 considers end-of-life issues, including treatment planning and care.
- It addresses decisions regarding life-sustaining treatment and ceiling of care.
- It describes the responsibilities of the clinical team when considering decisions not to attempt cardiopulmonary resuscitation (DNACPR) and provides advice for informing families and normalising discussion about DNACPR decisions.
- It describes the operational procedures for applications to the Court of Protection to withdraw CANH in the context of either VS or MCS.

This section also addresses care of the patient dying in PDOC and the particular challenges for palliative care in the context of elective withdrawal of CANH following Court approval.
- It describes the principles of palliative care and presents some questions frequently asked by families, suggesting some ways of answering them.
- It also sets out a detailed regimen for staged escalation of sedation and analgesia, using either a subcutaneous or intravenous route of administration, to manage any symptoms and signs of physiological distress in the terminal stages.

Section 6 describes commissioning and organisation of services for patents in PDOC.
- It proposes a network model in which highly skilled specialist staff in designated specialised services also provide outreach support to local teams in slow-stream rehabilitation and long-term care services.
- It also emphasises the requirement for a collaborative approach from both palliative care and neurorehabilitation teams in neuro-palliative and end-of-life care.

Finally, this section also addresses the requirement for further research and development to improve our understanding of PDOC including:
- the role of functional imaging and electrophysiology
- longitudinal evaluation through systematic cohort analyses to determine prognosis and survival
- identify the factors that predict recovery
- economic evaluation to identify cost-effective models of care
- optimisation of palliative care regimens to manage end-of-life care within different care settings.

It recommends the establishment of a national register and agreed minimum dataset for the collection of a national cohort of longitudinal outcome data for patients with PDOC, to be incorporated within the UK Rehabilitation Outcomes Collaborative (UKROC) national clinical database.

The guidelines are accompanied by a set of electronic annexes (listed in Appendix 2 and available online at www.rcplondon.ac.uk/pdoc) that provide further detail and practical advice to assist clinicians caring for patients in PDOC, as well as offering a guide for family and friends about their role in decision-making.

Section 1
Defining criteria and terminology

1 Introduction

Disorders of consciousness (DOC) include:

- coma
- vegetative state (VS)
- minimally conscious state (MCS).

Following severe brain injury, many patients progress through stages of coma, VS and MCS as they emerge into a state of full awareness. Some will remain in a vegetative or minimally conscious state for the rest of their lives. These guidelines concern the diagnosis, management and lifelong (including end-of-life (EOL)) care of adults who have prolonged disorders of consciousness (PDOC), persisting for more than 4 weeks following sudden onset profound acquired brain injury.

The brain injury may result from any cause. The major causes are listed in Table 1.1.

Table 1.1. Common causes of profound brain injury resulting in PDOC.

Aetiology	Examples
Trauma	Direct impact, or diffuse axonal injury resulting from rapid deceleration
Vascular event	Catastrophic intracerebral or subarachnoid haemorrhage, stroke
Hypoxic or hypo-perfusion	Due to cardiorespiratory arrest or profound hypovolaemia
Infection or inflammation	Encephalitis, vasculitis
Toxic or metabolic	Drug or alcohol poisoning, severe hypoglycaemia

PDOC may also occur in the final stages of dementia or other chronic progressive neurodegenerative disorders. However, the requirements for assessment and monitoring are clearly different in the context of a known deteriorating trajectory. Whilst the guidance for clinical and end-of-life care may also have applicability in progressive conditions, the primary focus of these guidelines is on sudden onset brain injury of any cause.

Definition of 'family'

Awareness may vary in patients with PDOC, but even if the patient has little awareness of their situation, their families often experience very severe distress requiring active support in their own right. They may need help to come to terms with the radical changes in their lives that result from a loved one's catastrophic brain injury. The children of patients with PDOC often have particular needs for support. Therefore, these guidelines address the needs of the family, as well as those of the patient.

Importantly, family and friends also play a key role in the clinical decision-making process as they provide important insights into the character, beliefs and likely wishes of the patient (see also Sections 3–5). The provision of timely information, education and support for families, and consultation with them, is therefore a critical factor for successful management and appropriate decision-making regarding care and treatment.

The term 'family' as used in these guidelines includes those people who have a sufficiently close relationship to the patient to be actively involved in their recovery, and a legitimate interest that permits disclosure of clinical information as a part of providing support and '*best interests*' decision-making (see Section 4). In this context, it is the social relationship that is crucial, rather than the more traditional definition of family as defined by genetic or legal relationships.

2 Definitions and characteristics

Consciousness is an ambiguous term, encompassing both wakefulness and awareness.[1]
- 'Wakefulness' is a state in which the eyes are open and there is a degree of motor arousal; it contrasts with sleep – a state of eye closure and motor quiescence.
- 'Awareness' is the ability to have, and the having of, experience of any kind.

There is no simple, single clinical sign or laboratory test of awareness. Its presence must be deduced from a range of behaviours which indicate that an individual can perceive self and surroundings, frame intentions and interact with others.

Terminology

In recent years, there has been a growing sense of discomfort in referring to patients as 'vegetative'. The Guideline Development Group (GDG) considered various alternative terminologies:
- Umbrella terms:
 - 'Low awareness state' has been used as a generic term for VS/MCS, until a more precise categorisation can be determined. The term is problematic as some patients will be completely unaware.
 - The US Task Force uses the term 'disorder of consciousness' (DOC).
- The European Task Force on Disorders of Consciousness has proposed the term 'unresponsive wakefulness syndrome' (UWS),[4] to replace that of 'vegetative state'. However, the term has yet to be fully defined.
 - The Task Force deliberately avoided the term 'unawareness', acknowledging that detailed evaluation will reveal a certain level of awareness in some patients.

- The term 'unresponsive' is problematic, however, as some patients show some level of response, albeit at reflex level.
- As yet there is no formal definition of 'persisting' or 'permanent' UWS.

Within these RCP guidelines:

- The terms '**vegetative state**' (**VS**) and '**minimally conscious state**' (**MCS**) are retained at the present time, as there are clear definitions for them and both the public and commissioners generally know what they mean.
- They should not be applied, however, until a formal diagnosis of 'continuing VS/MCS' has been made through careful serial assessment (see Section 2, Assessment and Diagnosis).
- Until then, the general term '**prolonged disorder of consciousness**' (**PDOC**) should be used to describe a disorder of consciousness that has persisted for at least 4 weeks post injury but is still under investigation.
- We accept that some families dislike the term 'vegetative state' – although others report that it is helpful (especially at the end of life) to understand that the patient is not aware and not suffering.
- If and when a more acceptable, internationally agreed term emerges, this will be adopted in future iterations of these guidelines.

For the purposes of this guideline we use the definitions shown in Table 1.2.

Table 1.2. Definitions of disorders of consciousness.

Coma (Absent wakefulness and absent awareness)	A state of unrousable unresponsiveness, lasting more than 6 hours in which a person: • cannot be awakened • fails to respond normally to painful stimuli, light or sound • lacks a normal sleep–wake cycle, *and* • does not initiate voluntary actions.
Vegetative state (VS) (Wakefulness with absent awareness)	A state of wakefulness without awareness in which there is preserved capacity for spontaneous or stimulus-induced arousal, evidenced by sleep–wake cycles and a range of reflexive and spontaneous behaviours. VS is characterised by complete absence of behavioural evidence for self- or environmental awareness.
Minimally conscious state (MCS) (Wakefulness with minimal awareness)	A state of severely altered consciousness in which minimal but clearly discernible behavioural evidence of self- or environmental awareness is demonstrated.[5] MCS is characterised by *inconsistent, but reproducible*, responses above the level of spontaneous or reflexive behaviour, which indicate some degree of interaction with their surroundings.

All 'disorders of consciousness' are quite distinct from 'locked-in syndrome' or 'brainstem death'.

- The **locked-in syndrome** (helpfully described by journalist Jean-Dominique Bauby in his book, *The Diving Bell and the Butterfly*[6]) usually results from brainstem pathology which disrupts the voluntary control of movement without abolishing either wakefulness or awareness. Patients who are 'locked in' are substantially paralysed but conscious, and can usually communicate using movements of the eyes or eyelids.

- **Brainstem death** implies the loss of all brainstem functions, as confirmed by the absence of brainstem reflexes (pupillary, corneal, oculovestibular and cough) and spontaneous respiratory effort in response to rising carbon dioxide levels. Patients with brainstem death may be maintained for short periods on artificial ventilation, to allow clinical and *best interests* decision-making, or support organ donation, but will inevitably cease to maintain physiological function within a relatively short period after withdrawal of ventilator support.

 By contrast, patients in VS/MCS may require a tracheostomy, but typically maintain their own cardiac output and respiration, and so may survive for months (or in some cases many years) without cardiorespiratory support.

Although these various states are reasonably easily distinguished, many clinical teams have little experience of diagnosing the nature of PDOC. Therefore, it is important to involve clinicians who are familiar with assessment of people with complex cognitive and/or communication impairments after profound brain injury, and who have specific experience and expertise in the assessment of PDOC.

3 Criteria for diagnosis of vegetative and minimally conscious states

Preconditions

The preconditions shown in Table 1.3 must apply.

Table 1.3. Preconditions for diagnosis of VS or MCS.

	Precondition	Detail
1	**Cause of condition known**	The cause of the condition should be established as far as is possible; eg brain injury, degenerative conditions, metabolic/infective disorders. (Occasionally a precise cause cannot be identified.)
2	**Reversible causes excluded**	The possibility of reversible causes must be excluded, including: • the influence of drugs • metabolic causes • treatable structural causes, eg collection of blood/hydrocephalus.
3	**Careful assessment**	The patient should be examined: • by trained assessor(s) experienced in the management of PDOC • under appropriate conditions (positioning, environment etc) • using validated tests, in a series of observations over an appropriate period of time. (See Section 2 for further detail on assessment.)

Criteria for VS[1]

The following are the essential criteria for VS. There is no evidence of:
1 awareness of self or environment or the ability to interact with others
2 sustained purposeful or voluntary behaviours, either spontaneously or in response to visual, auditory, tactile or noxious stimuli
3 language, comprehension or meaningful expression.

The following are also usually present:

1 cycles of eye closure and eye opening, giving the appearance of a sleep–wake cycle

2 spontaneous respiration and circulation.

Compatible features

Patients may also demonstrate a range of spontaneous or reflexive behaviours including the following:

Spontaneous movements

The following may occur for no discernible reason:
- chewing, teeth grinding, tongue-pumping
- roving eye movements
- purposeless movements of limbs and/or trunk
- facial movements, such as smiles or grimaces
- shedding tears
- grunting or groaning sounds.

Reflexive movements

The following reflexes are usually preserved:
- brainstem reflexes (pupillary, oculocephalic (doll's eye), oculovestibular (caloric))
- corneal reflex
- reflexive oral/facial reflexes (eg gag, saliva swallowing, tongue thrust, bite reflex, rooting, lip pursing)
- grasp reflex.

Various stimuli (eg noxious or noise) may produce a generalised arousal response, with:
- quickening of respiration
- grimaces, or
- non-localising limb movements (eg extension, flexor or withdrawal reflexes).

Eyes may turn fleetingly to:
- follow a moving object or towards a loud sound
- fixate a target
- react to visual menace

but they do not usually follow a moving target for more than a fraction of a second.

Compatible, but atypical features of VS

Patients have also been described in whom isolated fragments of behaviour, such as the utterance of a single inappropriate word, occur in what otherwise appears to be a VS. These features appear to reflect the survival of 'islands' of cortex, which are no longer part of the coherent thalamo-cortical system required to generate awareness.

Features of this kind should prompt careful reassessment of the diagnosis, but they do not in themselves negate the diagnosis of VS.

Incompatible features

Features that are incompatible with VS include:
- evidence of discriminative perception
- purposeful actions
- anticipatory actions
- communicative acts.

For example, a smile specifically *in response* to the arrival of a friend or relative would be incompatible with VS, whereas a spontaneous smile would be compatible.

Similarly, an attempt to reach out for an object or the appropriate use of language would indicate the recovery of some awareness of their surroundings, even though this may be very limited, and would be incompatible with VS.

Criteria for MCS

The definition of a **minimally conscious state** (MCS) was first published by the Aspen Neurobehavioral Conference Workgroup in 2002,[7] based on the requirement for at least one clear-cut behavioural sign of consciousness, indicating that patients retain at least some capacity for cognitive processing.

To make the diagnosis of MCS, limited but clearly discernible evidence of self- or environmental awareness must be demonstrated on an inconsistent, but reproducible or sustained, basis by one or more of the behaviours listed in Box 1.1.[5]

Box 1.1. Behaviours compatible with minimally conscious state (MCS).

1 Following simple commands.
2 Gestural or verbal 'yes/no' responses (regardless of inaccuracy).
3 Intelligible verbalisation (accepting inaccuracy due to specific speech or language deficits).
4 Purposeful or discriminating behaviour, including movements or affective behaviours that:
 - occur in contingent relation to relevant environmental stimuli, *and*
 - are not due to reflexive activity.

Any of the following examples provide sufficient evidence for a behavioural response that is only explicable through some awareness being present:
 (a) episodes of crying, smiling, or laughter in response to linguistic or visual content of emotional (but not neutral) topics or stimuli
 (b) vocalisation or gestures in direct response to the linguistic content of comments or questions
 (c) reaching for objects in a manner that demonstrates a clear relationship between object location and direction of reach
 (d) touching or holding objects in a manner that accommodates the size and shape of the object

continued

> **Box 1.1.** *continued*
>
> (e) sustained pursuit eye movement or sustained fixation that occurs in direct response to moving or salient stimuli
> (f) other localising or discriminating behaviours that constitute:
> • movement towards a perceived object, or
> • differential responses to different objects or people.

The reproducibility of such evidence is affected by the consistency and complexity of the behavioural response:[5]
 • Extended assessment may be required to determine whether a simple response (eg a finger movement or eye blink) that is observed infrequently is occurring in response to a specific environmental event (eg a command to move fingers or blink eyes) or on a coincidental basis.
 • In contrast, a few observations of a complex response (eg intelligible verbalisation) may be sufficient to determine the presence of awareness.

4 Subcategorisation of MCS

MCS encompasses a broad spectrum of responsiveness from a very low level (where patients start to show evidence of non-reflexive movements) to a higher level of meaningful interaction, albeit still inconsistent.

Bruno and colleagues (2011) recommended a division of MCS into '**plus**' and '**minus**' subcategories based on the level of complexity of observed behavioural responses:[8]
 • **MCS-plus** patients show more complex behaviours such as command following.
 • **MCS-minus** patients show only non-reflexive movements such as orientation to noxious stimuli, pursuit eye movements, etc.

However, categorisation of MCS is problematic as it could be based on a number of parameters including both the degree of consistency and the level of the behaviour. As yet there is insufficient evidence to know whether subcategorisation has any prognostic significance. More research is required in this area.

Based on current knowledge, the GDG does not recommend formal subcategorisation at present, but emphasises the need for consistent use of standardised tools (see Section 2) to define various levels of responsiveness/interaction and longitudinal evaluation to relate presentation to outcome.

5 Emergence from minimally conscious states

The hallmark of a minimally conscious state is that the interactions and behavioural responses are 'inconsistent, but reproducible'.

Emergence from MCS is signalled by the recovery of *reliable and consistent* responses. However, the upper border of MCS is sometimes hard to define.

The US Aspen Work Group[7] proposed that emergence from MCS is characterised by reliable and consistent demonstration of one or both of the following:

- **functional interactive communication** – which may occur through verbalisation, writing, yes/no signals, or use of augmentative communication devices
- **functional use of objects** – behavioural evidence of discrimination between at least two different objects.

Operational parameters

To facilitate consistent reporting of findings among clinicians and investigators working with patients in MCS, the Work Group proposed a brief set of operational parameters to be used for demonstrating the reliability and consistency of responses.

The GDG accepted the concern that patients with severe brain injury may have difficulty in answering yes/no questions accurately due to specific language deficits (such as aphasia),[9,10] and similarly their ability to carry out functional tasks may be limited by the absence of motor function or apraxia. In addition, there is evidence that familiar stimuli in an emotionally enriched context are more likely to elicit a response.[11,12] Therefore, we have recommended a slight expansion of the operational parameters, as summarised in Table 1.4. We also recommend the use of standardised sets of biographical and situational questions that are suitable for translation into different languages.

More detailed rationale and guidance on the operational parameters and their application is given in electronic annex 1a at www.rcplondon.ac.uk/pdoc.

We recognise that these additions may not go far enough for some clinicians. However, the GDG considers that patients who lack the ability to interact in a consistent and meaningful way remain vulnerable and in need of specialist care and support. For those whose interactive inability prevents the accurate determination of their level of awareness, the risk of lowering the bar for emergence from MCS could result in disadvantage if they then fail to qualify for the level of care and services for patients in PDOC detailed later in this report.

Table 1.4. Operational parameters for demonstrating response reliability and consistency.

Patients should demonstrate a consistent response in at least one of the following types:	
Functional use of objects	Generally appropriate use of at least 2 different objects on 2 consecutive evaluations (with or without instruction) Eg attempts to write using a pen or pencil *and* to use a comb or hairbrush
Consistent discriminatory choice-making	Consistently indicates the correct choice from 2 pictures or matches paired objects on 6/6 trials on 2 consecutive evaluations. (Use at least 3 different pairs.)
Functional interactive communication	
Evidence of awareness of self	Gives correct yes/no responses to 6/6 autobiographical questions on 2 consecutive evaluations*
Evidence of awareness of their environment	Gives correct yes/no responses to 6/6 basic situational questions on 2 consecutive evaluations

*NB When assessing awareness using forced-choice questions, the presentation must be counterbalanced: half the questions correct and half incorrect. Visual information should be presented in both left and right visual fields on each trial to prevent response bias (McMillan TM. *Brain Inj* 1997;11:483–90).

If and when a patient emerges from MCS, the operational parameters used to demonstrate this (as given in Table 1.4) should be formally recorded in the notes, dated and signed by the responsible clinician.

6 Prognosis for recovery

Before giving guidance on the circumstances under which VS and/or MCS might be regarded as permanent, we conducted a search on the available literature regarding prognosis for recovery.

Key findings were as follows:
- For both VS and MCS, the likelihood of significant functional improvement diminishes over time.[5,13]
- The cause of brain injury is a strong determinant of outcome for both VS and MCS. Patients with non-traumatic (eg anoxic brain or other diffuse) injury have a shorter window for recovery and greater long-term severity of disability than patients with traumatic injury.[13,14]
- For patients in VS, the large majority of those who regain consciousness have done so by 12 months for traumatic brain injury, and by 3 months for non-traumatic injury,[14,15] although one recent single-centre study identified a small group of patients with traumatic brain injury (n=6/50) who emerged to consciousness between 12 and 24 months.[16]
- The prognosis for recovery is more heterogeneous for MCS than for VS, although age and level of awareness may have some predictive value.[15,17]
- The majority (>60–72%) of reported cases of patients who have emerged from MCS have done so by 2 years after injury, with a further 30% emerging at 2–4 years.[15,17,18] Cases of MCS patients emerging after more than 5 years from injury have rarely been reported.
- In both VS and MCS, there are isolated reports of recovery of consistent consciousness even after many years,[19–21] but these are a rarity, and inevitably those who recover remain profoundly disabled.
- Any progression is likely to be gradual, and it is likely that patients emerging late from VS/MCS will have shown signs of increasing responsiveness, had these been evaluated systematically over time. A number of studies have highlighted the trajectory of recovery as a potential indicator of prognosis for recovery,[22] and have emphasised the importance of serial testing to look for trends towards improved levels of responsiveness.

Based on a large cohort analysis of 434 patients published by the US Multi-Society Task Force,[13] the American Academy of Neurology practice guideline (1994)[23] recommended that VS may be judged to be 'permanent' 12 months after traumatic brain injury or 3 months after non-traumatic brain injury.

The UK RCP guidelines (2003)[3] recommended a more cautious period of 6 months for non-traumatic brain injury. In the light of the documented late recoveries, it is important to view the temporal definitions as probabilities. The US Task Force emphasised that permanent VS refers to prognosis and identifies the point after which recovery of consciousness is 'highly improbable' but not impossible.[13,23]

A summary of the literature is given in electronic annex 1b at www.rcplondon.ac.uk/pdoc.

7 'Continuing' and 'permanent' disorders of consciousness

Previous guidelines, including those from the USA[13] and the UK,[3] have defined two states: 'persistent' and 'permanent' VS. These both carry the same acronym (PVS), which often leads to confusion. No published guidelines have yet attempted to define equivalent states for MCS.

The GDG considered that, although these definitions must be made with a degree of caution at the current time, they are helpful overall for the purpose of decision-making and commissioning. However, it recommended a reversion to the terminology used in the original RCP guidance,[24] replacing 'persistent' with 'continuing', both for VS and MCS, to avoid confusion when acronyms are used.

When a patient has remained in a state of wakefulness with reduced or absent responsiveness for more than 4 weeks, they may be classified as having a '**prolonged disorder of consciousness**'.

At this point it may not be possible to classify them reliably into VS or MCS.
- Research demonstrates that some patients in VS are either misdiagnosed or progress over time to a higher level of interactivity.[25]
- MCS represents a broad range of responsiveness (encompassing the gap between VS and emergence into a state of full awareness), which is characteristically inconsistent.

Therefore, the diagnosis of 'continuing' or 'permanent' VS or MCS should only be made by an appropriately experienced assessor, using formal diagnostic tools applied on repeated occasions over an appropriate period of time in conjunction with a detailed clinical neurological assessment (see Section 2).

Once this detailed assessment has been undertaken, patients may be diagnosed as having 'continuing' VS or MCS.

'Continuing' VS and MCS

A patient may be described as being in:
- '**continuing VS**' when they have continued to demonstrate complete absence of behavioural evidence for self- or environmental awareness for more than 4 weeks, or
- '**continuing MCS**' when they continue to demonstrate inconsistent, but reproducible, interaction with their surroundings (above the level of spontaneous or reflexive behaviour) for more than 4 weeks.

'Permanent' DOC

If the PDOC is deemed 'permanent', a prediction is being made that awareness will never recover. Although this prediction cannot be made with absolute certainty, when an individual has remained in steady state over a period of time, there comes a point after which recovery of awareness is highly improbable.

'Permanent' VS

Although the GDG recognised that cases of late recovery of consciousness have been reported, it did not recommend a change in the temporal criteria for diagnosis of permanent VS on the basis of current literature.
- A vegetative state may be classified as a '**permanent VS**' if it has persisted for:
 - >6 months following anoxic or other metabolic brain injury
 - >1 year following traumatic brain injury.

However, the GDG emphasised the need for careful individual evaluation taking into account the nature and severity of the injury and any trajectory of change over time, recorded through validated tests. The diagnosis can only be made once the patient is medically stable. These requirements are especially important where decisions regarding treatment and care are made on the basis of that diagnosis. In cases of genuine clinical uncertainty, a further period of targeted monitoring (eg for 6–12 months) may be appropriate before making a diagnosis of permanent VS.

'Permanent' MCS

The literature demonstrates heterogeneity with respect to prognosis for recovery, with poorer outcomes for those with non-traumatic brain injury.[14] Although there are documented cases of people with MCS emerging up to 4 years post injury,[15,17,18] the published evidence to date suggests that emergence is extremely rare after 5 years in MCS.

Whilst duration is clearly important, however, a number of other factors may also influence the point at which emergence may be regarded as 'highly improbable'. These include:
- the patient's general condition and any other comorbidities
- the nature and severity of the injury
- the level of responsiveness
- the observed trajectory of improving responsiveness over a period of months (or, in some cases, years).

The combination of these factors is likely to have stronger predictive value than a simple time limit.

The GDG recommended that further long-term cohort studies, based on systematically collected data, are required before definitive guidance could be given on the circumstances under which MCS should be regarded as 'permanent'. In the meantime, it offered the following advice:
- Regardless of aetiology, a patient who has remained in 'continuing MCS' for 5 years, with no demonstrable trajectory towards improving responsiveness on serial testing, emergence to a state of full consciousness may be regarded as 'highly improbable', so warranting a diagnosis of 'permanent MCS'.
- In certain circumstances (for example, severe anoxic injury with a prolonged 'down-time', or where a consistently low level of responsiveness is observed (eg all observed behaviours in the lower portion of the Wessex Head Injury Matrix (eg items 1–30), or SMART levels 1–3; see Section 2), the threshold for accepting that MCS is permanent may reduce to 3–4 years, or even less.

Section 1 Definitions and terminology: Summary of recommendations

	Recommendation	Grade
1.1	**For the purposes of these guidelines the following definitions will be applied:**	
	1 **Prolonged disorders of consciousness (PDOC)** Patients with prolonged disorders of consciousness (PDOC) are those who remain in a state of wakefulness but absent or reduced awareness (ie in a vegetative or minimally conscious state) for more than 4 weeks.	E1/2
	2 **Vegetative state (VS)** VS is defined as: *'A state of wakefulness without awareness in which there is preserved capacity for spontaneous or stimulus-induced arousal, evidenced by sleep–wake cycles and a range of reflexive and spontaneous behaviours.'* VS is characterised by a complete absence of behavioural evidence for self- or environmental awareness.	E1/2
	3 **Minimally conscious state (MCS)** MCS is defined as: *'A state of severely altered consciousness in which minimal but clearly discernible behavioural evidence of self- or environmental awareness is demonstrated.'*[5] MCS is characterised by *inconsistent, but reproducible,* responses above the level of spontaneous or reflexive behaviour, which indicate some degree of interaction with their surroundings.	E1/2
1.2	**Preconditions for diagnosis** 1 The following preconditions must be met before a diagnosis of VS or MCS can be made: 　a　The cause of the condition should be established as far as is possible. 　b　The possibility of reversible causes must be excluded. 　c　Assessment should be made under appropriate conditions by a trained assessor, experienced in PDOC, as described in Section 2.	E1/2
1.3	**Emergence from MCS** Emergence from MCS is characterised by reliable and consistent demonstration of *one or both* of the following: • **functional interactive communication** – which may occur through verbalisation, writing, yes/no signals, or use of augmentative communication devices • **functional use of objects** – behavioural evidence of discrimination between at least 2 different objects.	E1/2
1.4	**Operational parameters for demonstrating emergence** 1 The following operational parameters should be used for demonstrating reliable and consistent responses (see electronic annex 1a at www.rcplondon.ac.uk/pdoc for operational guidance): 　a　*Functional communication:* 　　• Correct yes/no responses to 6/6 basic situational orientation or autobiographical questions on 2 consecutive evaluations. 　b　*Functional object use:* 　　• Generally appropriate use of at least 2 different objects on 2 consecutive evaluations. 　c　*Consistent choice-making:* 　　• Indicating the correct choice from 2 pictures or matching of paired objects (at least 3 different pairs) on 6/6 trials on 2 consecutive evaluations.	E1/2

1.5 A state of VS lasting for more than 4 weeks may be classified as '**continuing VS**'. RA, E1/2

1 VS may be classified as '**permanent VS**' if it has persisted for:
- \>6 months following anoxic or other metabolic brain injury
- \>1 year following traumatic brain injury.

2 In cases of genuine clinical uncertainty, a further period of targeted monitoring (eg 6–12 months) may be required to make a diagnosis of permanent VS.

3 Recovery from permanent VS may be regarded as highly improbable.

1.6 A state of MCS lasting for more than 4 weeks may be classified as '**continuing MCS**'. E1/2

1 Further long-term cohort studies are required before definitive guidance can be given on the circumstances under which MCS should be regarded as 'permanent'. In the meantime the following advice is offered.

2 The point at which emergence from MCS may be regarded as 'highly improbable' is likely to depend on a number of factors including:
- the duration of MCS
- the patient's general condition and any other comorbidities
- the nature and severity of the injury
- the level of responsiveness, and
- any observed trajectory to improved responsiveness on serial testing.

3 Regardless of aetiology, a patient who has remained in continuing MCS for 5 years, with no demonstrable trajectory towards improvement, may be classified as 'permanent MCS'.

4 The threshold for diagnosis of 'permanent MCS' may reduce to 3–4 years, or even less, in certain circumstances which include:
- a severe diffuse injury (eg anoxic injury with a prolonged 'down-time')
- b a consistently low level of responsiveness is observed (eg all observed behaviours in the lower portion of the Wessex Head Injury Matrix , or SMART levels 1–3)
- c no trajectory towards improving responsiveness is seen on serial testing.

5 Recovery from 'permanent MCS' may be regarded as highly improbable.

Section 2
Assessment, diagnosis and monitoring

Vegetative and minimally conscious states (VS and MCS) must be distinguished from other conditions, including states of lifelong severe disability with preserved awareness, the locked-in syndrome, coma, and brain death confirmed by brainstem death testing. Table 2.1 summarises the key distinguishing features of these different conditions.

1 Diagnosis

Accurate diagnosis is required for clinical decision-making and treatment planning – and also on occasion for legal purposes, including applications to the Court for withdrawal of life-sustaining treatments.

There is no laboratory or clinical investigation that will confirm the diagnosis of VS or MCS – the diagnosis is made on the basis of careful clinical evaluation by appropriately trained professionals. Diagnosis rests on clinical observation of behaviours that may suggest awareness of self and the environment.

Accurate diagnosis is challenging in this context for a number of reasons:
- Profound motor and sensory deficits, or indeed aphasia,[26] may mask the behaviours that demonstrate awareness.[14]
- Responses are often delayed and inconsistent, and may easily fatigue.[27,28]
- Patients are often assessed too early, by inexperienced clinicians who are pressed for time – or at a time when patients are still medically unstable.

Misdiagnosis remains a significant problem in PDOC,[27,29,30] and may be the result of either diagnostic error or change in the patient's condition over time. Clinicians should be aware that, as a result of severe brain injury, patients may have specific language deficits or motor deficits (eg aphasia, apraxia) which may limit their ability to interact. Hence the requirement for *evaluation by a multidisciplinary team* of clinicians who are expert in assessing cognition, communication and motor function in the context of PDOC. Key disciplines include physiotherapy, occupational therapy, speech and language therapy, neuropsychology, nursing and rehabilitation medicine. However, diagnosis and management requires a team-based approach, and should not depend upon isolated individuals, whatever their profession and expertise individually.

Table 2.1. Differential diagnosis of prolonged disorders of consciousness.

Condition	Vegetative state (VS)	Minimally conscious state (MCS)	Locked-in syndrome	Coma	Death by confirmed by brainstem tests
Awareness	Absent	Present	Present	Absent	Absent
Sleep–wake cycle	Present	Present	Present	Absent	Absent
Response to noxious stimuli	+/-	Present	Present (in eyes only)	+/-	Absent
Glasgow Coma Scale	E4, M1-4, V1-2	E4, M1-5, V1-4	E4, M1, V1	E1-2, M1-4, V1-2	E1, M1-3, V1
Motor function	No purposeful movement	Some inconsistent verbal or purposeful motor behaviour	Volitional vertical eye movements or eye blink typically preserved	No purposeful movement	None or only reflex spinal movement
Respiratory function	Typically preserved	Typically preserved	Typically preserved	Variable	Absent
EEG activity	Typically slow wave activity	Insufficient data	Typically normal	Typically slow wave activity	Typically absent
Cerebral metabolism (PET)	Severely reduced	Intermediate reduction	Mildly reduced	Moderately to severely reduced	Severely reduced or absent
Prognosis	Variable: if permanent, continued VS or death	Variable: if permanent, continued MCS or death	Depends on cause but full recovery unlikely	Recovery, vegetative state or death within weeks	Organ function can be sustained only temporarily with life support

EEG = electroencephalography; PET = positron emission tomography.

The use of formal structured assessment tools may help to classify patients appropriately.[30] Because the emergence from coma or disordered consciousness is generally through a gradual process of recovery, serial observation to identify trends towards more consistent or higher-level responses provides the best indicator we currently have of whether or not an individual is likely to emerge from VS or MCS.[31,32]

Diagnosis cannot therefore be based on a single assessment, but is made by using and reviewing observations over an adequate period of time, using both detailed clinical evaluation and validated structured assessment tools.

Involvement of friends and family

Families and close friends play a key role in the assessment and diagnosis of patients with DOC because they are often present over prolonged periods, and because many patients respond at an earlier stage with familiar people. On the other hand, family members may sometimes interpret simple reflexive movements as more positive interactions. They need information and support from clinicians who can explain what behaviours to look for (see electronic annex 2e at www.rcplondon.ac.uk/pdoc).

It is often helpful to ask families to use videos to record their interactions, and/or to teach them how to use tools such as the Wessex Head Injury Matrix as a structured framework to record their observations, so that these can be reviewed and interpreted by the clinical team. Similarly the SMART-INFORMS presents a structured framework for documenting and interpreting the observations of families and friends. (See below for more information about these tools.)

2 Principles of clinical assessment

A person's level of awareness is judged on the basis of their behaviour, which requires that the person can receive at least some sort of sensory input and has control over at least some motor output. Misdiagnosis most commonly arises from failure to recognise that the patient is deaf, blind, aphasic or that responses are masked by paralysis, physical status or position.[29]

The diagnostic assessment process should follow a structured approach and should consider:
1 Causation
 a Before formal assessment, the cause of the brain damage must be established.
 b Any treatable causes/contributing factors to PDOC should also be ruled out.
2 Primary neurological pathways
 a Examination to determine the extent to which motor, sensory, visual and auditory pathways are sufficiently intact to allow evidence of awareness to be detected.
 b Evidence of specific localised damage may suggest specific impairments that might complicate the assessment to be accounted for during evaluation.[26]
3 Behavioural evidence of awareness/responsiveness
 • Indicating the extent to which the patient has self- or environmental awareness.
The framework for a standard clinical evaluation is given below.

A comprehensive scheme for clinical evaluation based on the principles above is given in electronic annex 2a at www.rcplondon.ac.uk/pdoc.

Standard clinical evaluation

A standard clinical evaluation should include the following:

1 **Detailed clinical history, examination and general investigation**
 - To identify the cause of brain injury and any complications arising from it.
 - To exclude other conditions (eg metabolic/infective disorders, hydrocephalus, 'syndrome of the trephined'[1]) that may impair consciousness.

2 **Review of medication**
 - To identify and, if possible, withdraw or reduce any drugs which could affect arousal.

3 **Standard imaging** (computed tomography or magnetic resonance imaging scan of the brain)
 - To exclude specific structural, operable causes (such as hydrocephalus) and localise areas of injury within the brain. Repeated imaging is not routinely required.

4 **Standard EEGs or trial of anticonvulsant**, if subclinical seizure activity is suspected.

5 **Detailed neurological evaluation** by an experienced clinician to include assessment of:
 - *primary visual pathways*:
 – pupillary light reflex, response to visual threat, or evidence of visual tracking.
 - *primary auditory pathways*:
 – startle or blink reflexes in response to sudden loud noises, or any evidence of localisation towards sound.
 - *primary somatosensory pathways*:
 – stretch reflexes, response (eg facial grimace) to touch or pain.
 - *primary motor output pathways*:
 – any spontaneous or reflexive movements of the face, mouth or limbs.
 - *spinal pathways*:
 – does limb pain cause facial movement and vice versa?

6 **Further investigations.** If any of these reflexes are absent, standard electrophysiological investigations (such as visual evoked potentials, auditory- or somatosensory-evoked brainstem potentials) may be used to investigate further whether the primary pathways are intact. This information may assist in the identification of the stimuli that may or may not be most likely to engender a response. However, electrophysiological tests do not form part of routine evaluation of patients with PDOC.

Clinical assessment of behavioural responses

The clinical assessment of the level of responsiveness and awareness depends on observation of behavioural responses. It is important to distinguish between:
(a) the actual behaviour observed, and
(b) the interpretations made from, or attributions placed on, the behaviour.

[1] 'Syndrome of the trephined' ('sinking skin flap syndrome') is a condition where neurological deterioration occurs following removal of a skull bone flap. It often manifests as patients becoming more sleepy as the skull defect sinks in when the patient is sat up. It may be partially or fully reversed by cranioplasty.

Three types of behavioural observations may contribute:
- spontaneous behaviours, not requiring external stimuli
- behaviours occurring in response to normal incidental stimuli
- behaviours occurring when using structured, planned stimuli.

Information may come from several complementary sources including:
- review of the clinical notes for routine observations recorded by staff during daily care and/or activities
- observations made by relatives and friends, usually gathered from interview, but sometimes systematically recorded by them
- observations made specifically by trained staff using both informal clinical evaluation and formal structured assessment protocols designed to investigate level of responsiveness.

Formal structured observational assessment of behavioural responses

Structured assessment using validated tools to quantify the level of response can help to reduce diagnostic error, and also provides a basis for recording change over time. Formal assessment using a structured behavioural assessment tool should be part of the overall assessment, but should not be the only assessment undertaken.

In order to encourage some degree of consistency for recording longitudinal outcomes, it is appropriate to agree a limited set of recommended instruments. Some of the tools can be time-intensive to administer, however, so a balance must be found between what is pragmatic to deliver and the need for standardised information for research and to inform clinical decision-making.

Formal assessment is essential in the following circumstances:
- to establish initial diagnosis and as a baseline to guide future management
- as part of a formal review of their clinical state when the patient has reached the end of the expected recovery period (see definitions of permanent VS and MCS in Section 1)
- as part of the assessment when making decisions about the potential withdrawal of active medical treatment (specifically clinically assisted nutrition and hydration (CANH))
- if there is significant disagreement between different parties on the clinical state (for example, if family members and clinical staff disagree).

It should also form part of monitoring during formal reviews in long-term care.

Assessment should be undertaken by a clinical team with specific training, skills and experience in the evaluation of patients with PDOC. Formal standardised evaluation should be performed under appropriate conditions with particular attention given to the following:
- **Health** – the patient is clinically well and free from inter-current infection.
- **Positioning** – the patient is supported in as upright a position as possible (preferably seated in an appropriately supported wheelchair/seating system).
- **Environment** – this is adequately lit, and free from noise and distraction.
- **Arousal** – choose times of day when the patient is most likely to be alert, avoiding sedative medication.

- **Avoiding overstimulation/fatigue** – assessment may need to be divided into short periods, with rest both prior to assessment and during any breaks.
- **Type of stimulation** – choose stimuli that the patient is familiar with (eg favourite music, familiar photos, known liked or disliked stimuli).

Minimum requirements for assessor training/experience are given in electronic annex 2b at www.rcplondon.ac.uk/pdoc. More detail on optimising conditions for assessment is given in electronic annex 2c at www.rcplondon.ac.uk/pdoc.

3 Diagnostic tools

The Glasgow Coma Scale (GCS) is widely used in acute settings to evaluate the level of consciousness. The GCS may be used as a screening tool to identify patients with PDOC, but patients in VS and MCS may exhibit any of the features highlighted in purple below, and so may have scores in the range of 3–12/15. It is therefore not a valid diagnostic tool for VS and MCS. It should also be noted that patients with locked-in syndrome may score lower than patients in PDOC.

Glasgow Coma Scale

Eye opening	Motor function	Verbal response
1 None	1 None	1 None
2 To pain	2 Extends to pain	2 Grunts/moans
3 To sound	3 Abnormal flexion to pain	3 Inappropriate words
4 Spontaneously	4 Normal flexion/withdrawal to pain	4 Confused
	5 Localises pain	5 Orientated
	6 Normal – follows commands	

Structured assessment tools

A recent review by the US Task Force[33] identified 13 instruments, of which six could be used to assess DOC with minor/moderate reservations:
- the JFK Coma Recovery Scale – Revised (CRS-R)[33,34]
- the Wessex Head Injury Matrix (WHIM)[28,35]
- the Sensory Modality Assessment and Rehabilitation Technique (SMART)[36,37]
- Western Neuro Sensory Stimulation Profile (WNSSP)[38]
- Sensory Stimulation Assessment Measure (SSAM)[39]
- Disorders of Consciousness Scale (DOCS).[40]

Validity, however, is not the only criterion on which tools may be chosen. Current usage is an important factor that influences the uptake of recommendations. A UK survey undertaken to support these guidelines[41] demonstrated that the WHIM is the most commonly used tool in the UK, followed by the SMART and then the CRS-R. Many centres specialising in this area use more than one of these tools, as they provide complementary information.

In order to support consistency, the GDG recommends the use of one or more of these three instruments for formal structured assessment of PDOC. However, the list is not intended to be exclusive. Clinicians may continue to use other instruments in addition to these if they find them helpful.

The Wessex Head Injury Matrix

The Wessex Head Injury Matrix (WHIM) is a 62-item hierarchical scale, which provides a sequential framework of tightly defined categories of observation covering an individual's level of responsiveness and interaction with their environment. Behaviours may occur either spontaneously or in response to stimulation.

Designed to be applied by different members of the multidisciplinary team, it was developed to monitor changes from coma through to emergence from post-traumatic amnesia in patients with traumatic brain injury. It is shown to be valid and reliable in this context,[28,35] but it also has applicability in other causes of PDOC.

The Sensory Modality Assessment and Rehabilitation Technique

The Sensory Modality Assessment and Rehabilitation Technique (SMART) is a detailed assessment and treatment tool developed to detect awareness, functional and communicative capacity in the VS and MCS patient, where there have been no consistent or reliable responses elicited and where the patient's potential function has not yet been fully explored.[36] It provides an extended graded assessment of the patient's level of sensory, motor and communicative responses to a structured and regulated sensory programme.

It comprises both a formal and an informal component:
- The informal component (**SMART-INFORMS**) consists of information from family and carers regarding observed behaviours and pre-morbid interests, likes and dislikes.
- The formal component is conducted by an accredited SMART assessor in 10 sessions within a 3-week period with an equal number of sessions in the morning and afternoon. It includes:
 - the **SMART Behavioural Observation Assessment** – a 10-minute quiet period, during which the assessor observes any reflexive, spontaneous and purposeful behaviours
 - the **SMART Sensory Assessment** examined across eight SMART modalities:
 o sensory modalities (visual, auditory, tactile, olfactory, gustatory), and
 o other modalities (motor function, functional communication and wakefulness).

Responses in each modality are assessed on the same 5-point hierarchical scale:
1 **No response** – to any stimulus
2 **Reflexive** and generalised responses, ie startle, flexor or extensor patterns
3 **Withdrawal**, eg turning head or eyes away or withdrawing limbs from a stimulus
4 **Localising** – eg turning head or moving upper limbs towards a stimulus
5 **Discriminating** responses, eg following visual or auditory commands or using object appropriately.

A consistent response (on five consecutive assessments) at SMART level 5 in any of the five sensory modalities indicates a meaningful response. These behaviours are inconsistent with VS and are indicative of MCS or higher levels of functioning.

JFK Coma Recovery Scale – Revised (CRS-R)

The JFK Coma Recovery Scale – Revised (CRS-R) has 25 hierarchically arranged items with 6 subscales (auditory, visual, motor, oromotor, communication and arousal).

- Scoring is based on the presence or absence of specific behavioural responses to stimuli presented in a standardised manner, from reflexive responses to cognitively facilitated responses.
- The revised scale was developed to differentiate between the diagnosis of VS and that of MCS and is shown to be valid and reliable in this context.[33,34]

Pros and cons of the various tools

There are pros and cons to the use of any of these tools, which may govern their selection by clinicians for routine use. In addition to the utility and cost considerations listed in Table 2.2, there are a number of practical considerations.

SMART

- The SMART is a detailed assessment tool designed to distinguish patients in VS from patients in MCS by evaluating behavioural responses.[42]
- The SMART was also designed to provide information on the patient's strengths and weaknesses in terms of responsiveness, to inform rehabilitation.
- The range of sensory modalities tested by the SMART can be useful when evaluating patients who may have sensory limitations (eg blindness).
- Family perspectives are recorded through the SMART-INFORMS.
- Stringent training and accreditation programmes (currently a 2–5-day training course with marked course work) ensure that the SMART is consistently applied by trained assessors, although this requirement has significant resource implications for clinicians' time.
- The prolonged assessment ensures that the assessor is very familiar with the patient's behavioural repertoire by the end of assessment, but it takes significantly longer than the other tools to deliver and document.

CRS-R

- The CRS-R is a simple tool, widely used in the USA, especially useful for tracking patients in the earlier stages of recovery.
- Although it lacks the range of sensory modalities accorded by the SMART, it covers a broadly similar range of responses.
- It may therefore have particular use for interim assessment between major time points when more detailed assessment is required.

WHIM

- The WHIM items covers a different range of responses from the SMART and CRS-R. Its ceiling extends beyond that of the CRS-R or SMART to track patients until they emerge from post-traumatic amnesia.
- Because it can be easily applied in the course of clinical practice by different members of the multidisciplinary team, the WHIM offers a simple practical tool for use in more generalist settings.

- Although not formally validated for this purpose, experience demonstrates that family members can also be trained quite easily to use the WHIM to record the responses that they observe.
- A serial record of WHIM scores can be used to monitor the consistency of responses, as well as trends towards change over time.[35]
- The WHIM has been criticised by some clinicians for its over-reliance on visual stimuli, and some items are noted to be out of order in the hierarchy. The originators are currently reviewing the WHIM to consider possible adjustments.

Recording over time

Inconsistency of response is a hallmark of MCS, so any structured assessment must be applied over time:
- The SMART formal assessment is conducted in 10 sessions within a 3-week period with an equal number of sessions in the morning and afternoon.
- If the CRS-R and/or WHIM are used as the basis for assessment, the GDG recommends that these should be applied on at least 10 occasions over a 2–3-week period – ideally at different times of day and in a variety of positions.

Table 2.2. Utility and cost considerations for the three structured assessment tools.

Reliability and validity	All three tools have acceptable published evidence of reliability and validity, and have been identified by Seel *et al*[33] as being appropriate for clinical practice with either minor (CRS-R), or moderate (SMART and WHIM) reservations.
Administration time	• The SMART takes on average 10–12 hours of trained therapy time to administer and document over the full 10-session course. • The WHIM and the CRS-R each take about 20 minutes to document systematically with formal testing of behaviours (so a total of about 3 hours to administer on 10 occasions).
Training and/or accreditation	• Training is not mandatory for the CRS-R or WHIM. Although training is shown to improve reliability,[28,34] and studies to date have been largely conducted with trained assessors, formal training programmes are not currently available in the UK. A training DVD for the CRS-R is available from the originators. • Training and accreditation is mandatory for the SMART. All practitioners need to complete the 2–5-day SMART assessor training and accreditation at the Royal Hospital for Neurodisability, Putney, or at local units as required.
Costs and copyright (Current at time of going to press. These may change over time)	• The CRS-R is not copyright restricted and is free to download and use. • The WHIM is copyright restricted. The manual and copies of the tool can be obtained from Pearson (www.psychorp.co.uk) at a cost of £51.50 for the manual and £1.64 per individual record sheet (providing 15 assessments). • The current cost of the SMART is £785 for the 5-day course, plus the SMART kit costs £499 (one per unit), which includes marking of pre-course work book, training and assessment, marking and adjudicating of portfolio, support, helpline for advice throughout accreditation process and afterwards. However, its use is being made freely available to a number of designated PDOC units around the UK. There is no extra charge for forms. There are 3 levels of SMART assessor with different requirements for training and accreditation. Further information on training may be obtained by emailing: smart@rhn.org.uk.

A more detailed comparison is given in electronic annex 2d at www.rcplondon.ac.uk/pdoc.

4 Long-term monitoring and repeat evaluation

Repeat clinical evaluation may be required for clinical and *best interests* decision-making, treatment planning, or to inform the Court.

Clinical re-evaluation for the purposes of treatment planning should be undertaken at 6 and 12 months post injury and annually thereafter. Assessment should be undertaken by an appropriately skilled assessor. It may be based on information gleaned from interviews with family members, carers and treating professionals.

Key features that families and care staff may be advised to look for are shown in Box 2.1.

Box 2.1. Features of responsiveness for families and care staff to look for.

1 **Do they show localising signs?**
 • eg move or look towards a specific stimulus (eg a sound), or
 • follow people with their eyes as they move around the room.
2 **Do they discriminate between different people?**
 • eg show preferential interaction with family or certain members of staff.
3 **Do they make purposeful movements?**
 • Do they reach out for objects, or
 • move appropriately in respond to command?
4 **Do they indicate yes/no?**
 • eg by gesture, eye-pointing blink etc.
5 **Do they show meaningful facial expressions?**
 • eg smile in response to a joke and cry/grimace in response to non-somatic stimuli appropriately (eg hearing bad news).

A more detailed list of screening items that the family and care staff can record is given in electronic annex 2e at www.rcplondon.ac.uk/pdoc.

The observed behaviours may be mapped on to the CRS-R (for international comparison) and/or WHIM to observe for trends of change over time.

Use of structured tools to inform decision-making

To inform key clinical and *best interests* decision-making, detailed clinical assessment and formal application of validated tools should be undertaken at the following key time points post injury.

(a) For patients in suspected VS:
 • 6 months – following non-traumatic brain injury
 • 12 months – following traumatic brain injury.

In cases of genuine clinical uncertainty about the diagnosis, a further period of targeted monitoring (eg 6–12 months) may be required as highlighted in Section 1.

(b) For patients in suspected MCS:
- 3–5 years – following brain injury, depending on:
 - the nature and severity of the injury
 - the level of responsiveness
 - the trajectory of change in the first 3 years.

A summary of the key time points for evaluation of patients in VS and MCS is shown in Fig 2.1.

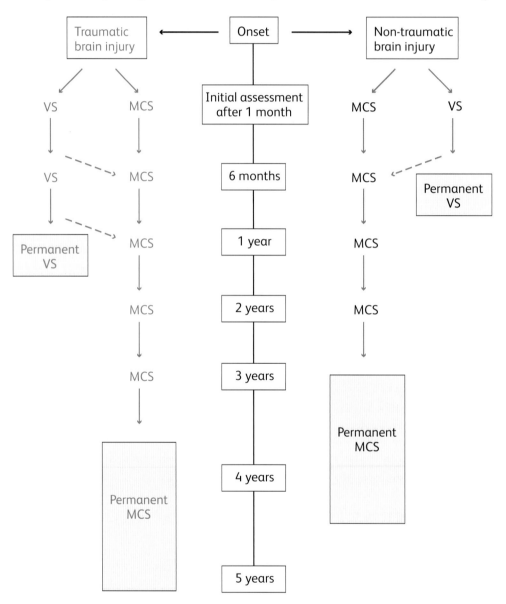

The timing for assessment for a diagnosis of permanent MCS will depend on
- the nature and severity of the injury
- the level of responsiveness *and*
- any observed trajectory to improved responsiveness on serial testing

Fig 2.1. Key time points for assessment and diagnosis.

As outlined above, the various structured assessment tools each provide complementary information that can help to support the diagnosis of VS or MCS, but none of them are diagnostic in their own right.

The choice of tool(s) will depend on:
- the degree of certainty of diagnosis needed for the decision in hand, and
- the level of contention.

For example, assessment to support applications to the Court of Protection for withdrawal of clinically assisted nutrition and hydration (CANH) has critical impact on a serious and irrevocable decision. The Court will rightly expect a high level of certainty with respect to diagnosis.

In this situation:
- If clinical evaluation, the WHIM and CRS-R all confirm VS and family, carers and clinicians are all agreed that there is no interaction, then a SMART is unlikely to add anything further.
- However, if there is any uncertainty or disagreement on the level of responsiveness, then SMART testing may be helpful to resolve this.

Formal evaluation should be signed by a consultant in rehabilitation medicine with experience in management of PDOC (see electronic annex 2f for proforma at www.rcplondon.ac.uk/pdoc).

National register and database

At the current time, there is a dearth of information on long-term outcomes for patients with PDOC in the UK. Systematically collected longitudinal data are required to identify patients with PDOC, and to track them through the course of their condition until they either emerge from PDOC or die.

The GDG recommends the establishment of a national register and agreed minimum dataset for the collection of a national cohort of longitudinal outcome data for all patients in PDOC.

All patients who are in VS or MCS at the end of their initial assessment should be entered into the register, and reviewed at least annually until either they emerge from PDOC or die.
- The database should include the results of the formal assessments undertaken (WHIM, CRS, SMART etc).
- To provide robust information on longitudinal outcomes, and in view of the documented late recoveries, annual reviews should ideally continue to include information mapped on to the WHIM or CRS, even after the diagnosis of permanent VS/MCS.

Recommendations for procurement and provision of the national database are addressed in Section 6. Updates on development of the register and details of how and where to register patients once the database is established will be available on the UK Rehabilitation Outcomes Collaborative (UKROC) website: www.csi.kcl.ac.uk/ukroc.html.

5 Imaging and electrophysiology

Imaging may be structural or functional.
- Structural imaging offers a vision of the structure of the brain to enable diagnosis of larger-scale diseases, tumours, injuries, and stroke. Recent techniques, such as diffusion tensor imaging (DTI), allow more detailed visualisation of the neural tracts.
- Functional imaging allows us to visualise the relationship between activity in certain brain areas and specific sensory stimuli or mental functions.

The role of functional imaging (such as functional magnetic resonance imaging (fMRI) and positron emission tomography (PET) scans) and **electrophysiology** has been under investigation for some 15 years.[43–45]

The potential advantage of these approaches is that they can be used to demonstrate distinct and specific physiological responses (eg changes in regional blood flow) in response to specific external stimuli, in the absence of any discernible behavioural response.

Brain imaging

Over 50 peer-reviewed imaging studies with patients considered to meet the criteria for VS and MCS have been published since 1987. The largest number of publications has been seen over the last decade using fMRI to probe defined cognitive networks and explore their relationship to behavioural response and recovery. For example:
- In a collaborative study between the groups in Cambridge and Liege, fMRI was used to assess each patient's ability to generate wilful responses (detected by neuroanatomically specific changes in blood-oxygenation level) during two established mental imagery tasks. Of 54 patients with DOC, five were able to modulate wilfully their brain activity. Three of these also showed behavioural evidence of awareness, but the other two did not. One patient was able to use the technique to answer simple yes/no questions during fMRI, although no form of communication could be established at the bedside.
- In the series from Cambridge, the level of auditory processing revealed by fMRI correlated strongly ($r = 0.81$, $P<0.001$) with the patient's subsequent behavioural recovery, 6 months after the scan.[43]

However, over the last two years research has started to move away from activation studies to explore the underlying structural integrity of defined cortical networks that are thought to be related to the maintenance of consciousness.
- A recent small study of diffusion tensor imaging (DTI) (n=25) from the same group showed a strong correlation between the structural integrity of white matter in the subcortical and thalamic regions and the diagnosis of VS and MCS, distinguishing the two conditions with 95% accuracy.[46]

These are passive examinations, which do not require the patient to respond and may have potentially greater clinical application than activation studies, because imaging may be undertaken in non-research/non-specialist centres.

The overwhelming consensus of clinical commentary and peer review is that brain imaging has provided valuable insights into this patient group, and will continue to provide an important focus for research. However, it has not yet reached a stage of development where it could be considered as part of routine clinical practice.

- The clinical significance and validity of the imagery findings have not yet been established.
 - There may be clear discordances between clinical state and the findings from functional imaging in individual patients. Particular caution is required when interpreting negative results. About one in five normal volunteers are unable to generate fMRI activity on motor imagery tasks, so negative results in an MCS patient do not necessarily indicate lack of awareness.
- Although carefully designed and interpreted functional brain imaging paradigms can potentially offer useful additional information to the clinical assessment, they are costly to implement and infrastructure to support the paradigms published to date is not present in most clinical MR centres.
- They are also time-consuming to apply (typically at 1–2 hours) and by no means all patients are suitable:
 - Patients who have implanted metal work (including programmable shunts), or are unable to tolerate lying supine for at least an hour are unsuitable for the technique.
 - A requirement for regular suctioning (eg of a tracheostomy) greatly prolongs the examination time because every time a patient is removed from the scanner to suction, a repeat structural and positioning scan are required, which can take about 30 minutes
 - Involuntary movements such as spasm, teeth-grinding or regular head rotation/extension, have obvious detrimental effects on the quality of data.[47]

Electrophysiology

Electrophysiological approaches have been under exploration in the PDOC literature for longer than dynamic imaging, with much of the literature dating back to the 1970s.

Although patients with VS and MCS show a variety of abnormalities on electroencephalography (EEG), the resting EEG has generally not been considered to have discriminating utility in this context. Its main application is in the acute environment, for example to exclude subclinical seizure activity, metabolic encephalopathy etc as a prerequisite for assessment.

However, there may be significant differences in sleep-related EEG activity. Despite observed behaviours that suggest sleep–wake cycles in VS patients, the majority of EEG studies have failed to find corresponding sleep phenomena (ie EEG patterns associated with rapid eye-movement (REM) and non-REM sleep, slow wave activity etc), although MCS patients may have more normal EEG patterns. In a recent study of 11 patients with PDOC by Landsness et al 2011,[48] EEG evidence of sleep phenomena was found in all six MCS patients but none of the five VS patients, suggesting that this might have discriminative value.

Sensory evoked potentials (SEPs), such as visual, brainstem auditory and somatosensory evoked potentials, are recognised as useful objective measures of the integrity of basic sensory pathways, and may assist in the interpretation of behavioural measures, through establishing the integrity of sensory pathways – in particular helping to avoid misdiagnosis due to visual impairment.

Cognitive evoked potentials (CEPs) offer bedside measures of basic higher order function, such as aspects of language processing. Protocols are rather more standardised than for fMRI, although the stimuli may vary. P300 is an event-related potential, elicited in the process of decision-making, and mismatch negativity (MMN) is a component of this that has been demonstrated in numerous studies with VS patients – essentially corroborating fMRI evidence of instances of preserved islands of higher order function.

Like fMRI, brain–computer interface (BCI) methodology therefore has the potential to measure aspects of awareness, without requiring the patient to move, but to date this has only been used with a small number of patients. There is little evidence at present to suggest that this provides any additional information above that obtained with behavioural measures, and international consensus is required on a standard set of paradigms to use in this context.

Summary of current status

Although accumulated evidence from electrophysiology and brain imaging (particularly fMRI) has been encouraging, it is still based on relatively small numbers of patients. It remains unclear whether brain imaging is capable of informing the diagnosis beyond clinical and behavioural assessment and whether these techniques have any prognostic utility.[43]

More work is required to improve our understanding of whether and how these investigations could contribute to decision-making in VS and MCS. At present, they do not form part of the standard assessment battery and should be only applied in the context of a registered research programme.

Until there is international consensus on a validated portfolio of paradigms for routine clinical use, it is appropriate that these imaging techniques should only be used in specialist research units with the experience and knowledge to perform and interpret these data. This is necessary to guard against the use of poorly designed paradigms and incorrect interpretation.

Imaging and other techniques *must* be accompanied by optimised clinical evaluation (as described in subsection 2, Principles of clinical assessment) so that data on the clinical validity of these tests can be accumulated. This requires expert multidisciplinary assessment by appropriately experienced staff in specialist centres, conducted systematically using validated structured tools and repeated over adequate periods of time, as described earlier in this section.[25,30]

6 Interventional programmes

Medication

A number of recent systematic reviews have explored the evidence for effectiveness of interventions for PDOC including a variety of medications, neurostimulation and sensory stimulation programmes.[49–52]

The evidence base from the literature may be summarised as follows:

1 Medications that have been explored include:
 - dopaminergic drugs (levodopa, amantadine and bromocriptine)
 - gaba-ergic drugs (eg zolpidem)

- medications that inhibit the reuptake of serotonin and/or noradrenaline in the presynaptic nerve terminal (eg methylphenidate, serotonin reuptake inhibitors).

2 Much of the research is limited, being based on single-case/open-label studies. Overall the evidence for their effectiveness is weak or conflicting:
 - Initial enthusiastic reports of extraordinary zolpidem-induced arousal from a semicomatose state[53,54] have not been replicated, although a small proportion of patients may exhibit a transitory response.[55]
 - Methylphenidate may improve attention and speed of mental processing in higher-level brain-injured patients,[56] but does not appear to improve responsiveness in patients with PDOC.[57]
 - In a multicentre open-label study, amantadine given for 4 weeks was found to be associated with an earlier recovery.[58] Preliminary results from controlled trials suggest positive effects both for adults and children.[59–61] Its longer-term effects require further exploration.

3 At the current time, there is insufficient evidence to make formal recommendations regarding the use of medication to enhance arousal/awareness.

The question of whether or not to try medication, and choice of agent, is a matter for clinicians to decide, in conjunction with families, on the basis of the patient's best interests. If the decision is made to prescribe medication, this should be on the basis of a therapeutic trial (A-B-A design), using a single agent at a time, with formal monitoring (eg with the WHIM or CRS-R administered daily) to observe the impact of the medication, preferably by observers unaware of when active treatment is started and finished.

Neurostimulation

A variety of techniques applying direct electrical or magnetic stimulation of the brain have been explored, including deep brain stimulation,[62] dorsal column stimulation,[62] and transcranial magnetic stimulation.[63]

The cumulative evidence from 202 patients in an uncontrolled case series suggested that approximately 20% of patients may make small gains in motor or verbal function.[49] However, the gains are modest for the most part and there are significant ethical concerns about the use of invasive techniques such as electrode implantation in patients who are unable to give consent to treatment, when the balance of benefits and harms is unknown.[64] Such techniques should therefore only be used as part of an ethically approved and registered research programme.

Sensory stimulation, including oral feeding

The human brain grows and adapts through use and is responsive to external stimulation.[65] Consequently, many authors have employed sensory stimulation programmes to try to enhance responsiveness.[38]

The evidence base from the literature may be summarised as follows:

1 In a group of acute patients, Doman *et al*[66] demonstrated striking results on 200 brain injured patients with a GCS <6 for up to 1 week following injury.
 - 91% of patients emerged from a coma through multisensory stimulation as compared to none of the control group, consisting of only 33 patients.

• However, this was a group in which spontaneous recovery would be expected. The small size of the control group, and its selective non-randomised nature, imposes a clear research bias.

2 Wood (1991)[67] poses a note of caution, believing that patients exposed to an undifferentiated bombardment of sensory information lose the ability to process information due to habituation. He recommended that stimulation programmes, if offered at all, should be delivered in a controlled and monitored manner.[68]

3 A Cochrane systematic review in 2004[52] found only three relatively low-quality controlled studies of coma arousal programmes and concluded that there is still no reliable evidence to support or rule out the effectiveness of multisensory programmes for patients in coma or vegetative state. Therefore, although widely advocated in expositions of 'good practice', research has yet to clearly demonstrate the efficacy of sensory stimulation.

Despite the lack of formal research evidence to support coma stimulation programmes, controlled stimulation probably provides the best opportunity to observe responses. Some families and friends may welcome the opportunity to have a positive role to offer during visiting times.

Many patients with PDOC demonstrate a degree of hypersensitivity, so care should be taken to avoid over-stimulation, or bombardment with multiple stimuli at the same time, as these can trigger sympathetic overactivity. In general, stimulation should focus on pleasant sensations (such as favourite music, familiar pets, gentle massage etc) offered one at a time for short periods to minimise sensory overload.

In particular, oral feeding might elicit behaviours such as anticipatory mouth opening, or watching the spoon approach, and (used cautiously taking into account the ability to swallow) it may provide useful additional evidence of interaction in some patients.

7 Other structured assessments – symptom monitoring

A particular concern for families and those caring for patients with PDOC is that they may be experiencing unpleasant symptoms such as pain and depression. Even though patients in VS are considered to be unaware, and therefore unable to experience the emotional consequences of pain, they may display physiological signs suggestive of pain. This overriding concern often results in clinicians prescribing pain relief, if only to reassure families and themselves.

The evidence available suggests that patients in MCS may have unimpaired ability to experience pain (and presumably other symptoms).[69] By definition, however, they are unable to report their pain symptoms reliably, so assessment must rely on the observation of pain-related behaviours. Clinicians are urged pay careful attention to the prevention, management and monitoring of pain/discomfort for patients with PDOC (see Section 4).

Pain

Schnakers et al have developed the Nociceptive Coma Scale[70] as a tool to assess awareness or response to nociception (fingernail pressure) in patients with PDOC. To date, however, there are no validated tests for the evaluation of pain symptoms in PDOC.

- The Scale of Pain Intensity (SPIN) is a visual analogue scale designed to facilitate pain reporting for patients with communication and cognitive deficits,[71] which may potentially be used in some higher-level MCS patients with appropriate facilitation.
- A number of assessment tools have been developed for patients with advanced dementia who cannot communicate their symptoms. These include the Abbey Pain Assessment tool[72] and the Pain Assessment in Advanced Dementia (PAIN-AD).[73]

In the context of PDOC, behaviours that are normally associated with pain may occur spontaneously as a result of reflex activity undamped by cortical inhibition, so the signs must be interpreted with caution. Further, changes associated with spontaneous or induced sympathetic overactivity (usually associated with hypothalamic damage) will give rise to signs similar to those induced by pain.

Neither the Abbey tool nor the PAIN-AD is directly transferable to patients with PDOC, but the tool shown in Table 2.3 is a hybrid of the two, adapted for this context. It has yet to be formally validated, but is proffered in the meantime as a structured framework for recording and monitoring behaviours that may denote the experience of pain in patients with MCS.

Table 2.3. Behavioural pain assessment tool for patients in MCS.*

Items	0	1	2	Score
Breathing (Independent of vocalisation)	Normal	Occasional laboured breathing. Short periods of hyperventilation	Noisy laboured breathing. Long periods of hyperventilation	
Negative vocalisation	None	Occasional moaning or groan	Loud moaning or groaning. Crying	
Facial expression	Smiling or inexpressive	Sad, frightened, frown, mild facial grimacing	Marked facial grimacing in response to presumed painful stimuli	
Body language	Relaxed/calm	Tense. Fidgeting	Rigid. Marked tonal posturing	
Consolability	No need to console	Distracted or reassured by voice or touch	Unable to console, distract or reassure	
Physiological change	Normal	Mild increase in vital signs (temperature, pulse, BP etc)	Marked increase in vital signs, or sweating, flushing/pallor	
Presence of painful conditions	None	Mild changes, eg marked skin, previous healed injuries, mild contractures	Marked changes, eg broken skin, active arthritis or heterotopic ossification, severe arthritis/ contractures	
TOTAL				/14

*Developed on the Regional Rehabilitation Unit, Northwick Park Hospital.

As yet, no data are available to support interpretation of scores, but the tool may nevertheless have practical value for monitoring change in pain-related behaviours, for example in response to analgesia.

Mood

Mood assessment is similarly challenging. There is no literature addressing the assessment of mood specifically in patients with PDOC, so the following information represents opinion only.

The RCP has published concise guidance on evaluation of mood in patients with acquired brain injury,[74] but again the overlap between signs of low mood and deficits arising from the brain injury itself tends to confound evaluation.

- The Depression Intensity Scale Circles[75] is a visual analogue scale (analogous to the SPIN) which again may be used in some patients with higher level MCS with appropriate facilitation.
- For those with no communication ability, the guidance recommends use of the Signs of Depression Scale[76] as a brief screening tool to record features that may be associated with low mood. Two of the items ('lethargy/reluctance to mobilise' and 'needing encouragement to do things for him/herself) are clearly inappropriate for patients with PDOC. However, the remaining four items may have relevance in this context, and their recording at least encourages staff to be aware of the possibility of low mood.

Signs of Depression Scale in PDOC

1 Does the patient sometimes look sad, miserable or depressed?	Yes/no
2 Does the patient ever cry or seem weepy?	Yes/no
3 Does the patient seem agitated, restless or anxious?	Yes/no
4 Does the patient seem withdrawn, showing little interest in the surroundings?	Yes/no
(This may include evidence of deliberate withdrawal from interaction, eg eye closure when approached by staff.)	
(Score 1 for 'yes' and 0 for 'no')	**Total score**

The use of antidepressants is controversial in this context. Although depression is a recognised complication of brain injury, it is frequently not responsive to medication. Moreover, antidepressant medication may also have unwanted effects (including sedation and lowering the threshold for seizure activity) and there are conflicting reports of its effect on neuroplasticity.

Clinical teams should be vigilant to the possibility of depression. If medication is considered, it should be used in line with the RCP guidelines.[74] These include a period of watchful waiting and regular formal review of mood (eg using the above Signs of Depression Scale). If there is no clear evidence of response within 4 weeks of starting the medication it should be withdrawn. Similarly, all courses of antidepressant medication should be time-limited, with a clear end point (maximum 6 months) after which medication should be gradually weaned off and withdrawn.

Section 2 Assessment and diagnosis: Summary of recommendations

	Recommendation	Grade
2.1	**Referral for specialist assessment** 1 Following severe brain injury, patients who remain in a state of wakeful non-responsiveness for more than 4 weeks should be referred to or transferred to a unit specialising in the multidisciplinary assessment/management of prolonged disorders of consciousness (PDOC), for detailed clinical evaluation.	E1/2
2.2	**Exclusion of treatable causes of PDOC** 1 Assessment should include the following to identify the cause of the brain damage and rule out treatable causes of PDOC: a CT or MRI scan of the brain to exclude haemorrhage or hydrocephalus (if not already undertaken in the acute phase) b Clinical evaluation to confirm that the sensory, visual and auditory pathways are intact c General investigation to exclude metabolic/infective disorders d Review of medication to stop or reduce any non-essential drugs which could affect the level of consciousness e EEGs or trial of anticonvulsant therapy, if subclinical seizure activity is suspected.	E1/2
2.3	**Diagnosis of vegetative state (VS) or minimally conscious state (MCS)** The mainstay of diagnosis is clinical evaluation for evidence of localising or discriminating behaviours indicating awareness of self or the environment. 1 Diagnosis of VS or MCS should be based on assessment: a by appropriately trained clinicians, experienced in PDOC • under suitable conditions • using validated structured assessment tools (see recommendation 2.5) • in a series of observations over an adequate period of time b in conjunction with clinical reports of behavioural responses gleaned from: • the care records • interviews with family members/care staff.	RA E1/2
2.4	**Involvement of families** Families play a key role in the assessment of patients with PDOC because patients may respond at an earlier stage to their families/loved ones. 1 Families should be actively involved in the assessment of patients with PDOC. 2 Clinicians should work closely with the family members, explaining a what behaviours to look for b how to distinguish higher level responses from reflex activity. 3 Where appropriate, families may also be encouraged to use tools such as the WHIM or videos to record their observations.	E1/2
2.5	**Structured tools for assessment of PDOC** 1 One or more of the following tools should be used during evaluation to confirm the diagnosis of VS or MCS: a the Wessex Head Injury Matrix (WHIM) b the JFK Coma Recovery Scale – Revised (CRS-R) c the Sensory Modality Assessment and Rehabilitation Technique (SMART). 2 Assessment using one or more of these tools should be undertaken: a under suitable conditions (see Section 2, and electronic annex 2c at www.rcplondon.ac.uk/pdoc) b on at least 10 occasions over a minimum of 2–3 weeks c at several different times of day.	RA E1/2

2.6 **Advanced imaging/electrophysiology** E1/2

 1 Whilst evidence from electrophysiology and advanced brain imaging (such as fMRI, DTI) has
 been encouraging it is not yet clear whether these techniques have any diagnostic or
 prognostic utility over and above expert clinical and behavioural assessment.
 a They do not form part of the standard assessment battery for PDOC at the current time.
 b Further work is required to understand the relationship between these techniques and the
 formal clinical evaluation tests.
 c In the meantime, they should be only applied in the context of a registered research
 programme and in conjunction with formal clinical evaluation as described in
 recommendation 2.3 above.

2.7 **Use of stimulation** E1/2

Despite the lack of formal research evidence to support coma stimulation programmes, controlled
stimulation provides the best opportunity to observe responses.

 1 The following pragmatic advice is offered to optimise the patient's environment:
 a Staff and families should be mindful of hypersensitivity and fatigue, and should avoid
 overstimulation.
 b Stimulation should focus on pleasant sensations such as favourite music, familiar pets,
 gentle massage etc, offered one at a time.
 c Family/friends should be asked to control their visits to avoid sensory overstimulation –
 with only 1–2 visitors at a time, visiting for short periods.

2.8 **Medications** RA
 E1/2

There is insufficient evidence to make formal recommendations with respect to the use of
medication to enhance arousal/awareness, although emerging evidence from recent trials
suggests that at least some patients may benefit from amantadine.

 1 The decision of whether or not to try medication, and choice of agent, is a matter for clinicians
 to decide, in conjunction with families, on the basis of the patient's best interests and any
 emerging evidence for effectiveness.
 2 If the decision is made to prescribe medication, this should be on the basis of a therapeutic trial
 (A-B-A design), using a single agent at a time, with formal monitoring to observe the impact of
 the medication.

2.9 **Repeat evaluation** E1/2

Repeat evaluation may be required for clinical decision-making/treatment planning, or to inform
the Court of Protection. The choice of tool(s) will depend on:
- the degree of certainty of diagnosis needed for the decision in hand, and
- the level of contention.

A 1 Clinical re-evaluation for the purposes of treatment planning should be undertaken at the E1/2
 following key time points:
 a at 6 months post injury
 b at 12 months post injury
 c annually thereafter until the patient emerges from PDOC or dies.
 2 Assessment may be based on information gleaned from interviews with family members,
 carers and treating professionals and should be mapped on to WHIM and/or the CRS-R (for
 international comparison).
 3 If and when a patient emerges from MCS, the operational parameters used to demonstrate
 this (as in Table 1.4) should be formally recorded in the notes, dated and signed by the
 responsible clinician.

B 1 For decisions to inform the Court, assessment through full clinical evaluation and using formal E1/2
 application of validated tools should be undertaken at the following key time points post
 injury:
 a For patients in suspected VS:
 • 6 months – following non-traumatic brain injury
 • 12 months – following traumatic brain injury.
 b For patients in suspected MCS: between 3 and 5 years depending on aetiology, level of
 responsiveness and any trajectory of change.
 c Diagnosis of permanent VS/MCS requires that the patient is medically stable at the time(s)
 of assessment.
 2 Assessment to inform applications to the Court for withdrawal of clinically assisted nutrition
 and hydration (CANH) has critical impact and should include formal evaluation using at least
 two of the recommended tools in recommendation 2.5.
 a Where there is any uncertainty or disagreement, SMART testing may help to resolve this.

2.10 Other assessments: symptoms such as pain and depression RB
 E1/2
 1 Clinicians should be aware that patients with PDOC may suffer from pain and depression, but
 be unable to report them.
 2 Careful attention should be paid to the prevention, management and monitoring of these
 symptoms – including the use of structured tools to screen for their presence, as described in
 Section 2.

Section 3
Care pathway – acute to longer-term management

1 General principles of care

Many patients who are unconscious in the early stages after the onset of brain injury will regain consciousness and awareness and will recover sufficiently to require specialist neurological rehabilitation and may well return home to independent or semi-independent life.[77] It is therefore important to avoid preventable complications earlier in the pathway, which might prolong hospital stay and prolong active rehabilitation, and may even reduce the eventual level of independence.

The need for adequate specialist neurological rehabilitation services has been widely acknowledged in many national documents (including NICE guidance[78] and the recent Department of Health policy on major trauma networks[79]). For those who remain in PDOC, proper management will not only avoid the development of complications, but will also simplify and shorten the eventual full assessment. However, it is recognised that the current level of provision of these services is insufficient to meet demand.

Patients with PDOC most commonly have sudden onset of catastrophic disability. They have complex needs for care and treatment (medical, nursing, therapies etc) requiring the highly specialist skills of a multidisciplinary team. As it is often unclear in the early stages which patients will and will not regain full consciousness, it is important that their early post-acute care is provided in a specialist rehabilitation setting where they can be fully assessed and an appropriate care programme put in place.

Although unable to participate in active goal-orientated rehabilitation, patients in PDOC require a coordinated multidisciplinary approach to disability management[80] delivered by staff with specialist training in the management of complex neurological disability, who also have the skills to assess and monitor their level of responsiveness (see Section 2). A further important role for the team is to provide practical information and emotional support for families, as well as to gather information from families to ensure appropriate *best interests* decision-making.

Once this initial stage is complete, it is usually appropriate to transfer patients to an appropriately skilled longer-term care setting, where they will continue to require a maintenance therapy programme and vigilant monitoring to watch for signs of returning awareness.

Although every patient should be seen by a specialist PDOC service (directly commissioned by NHS England), the majority of their care may appropriately be given outside such a service. This section is

therefore of particular relevance to local commissioners (such as clinical commissioning groups (CCGs) in England) and to the relatively non-specialist services that often manage these patients, both in the early phases and often in the longer term.

A proportion of the guidance in this section is not specific to people in PDOC, but concerns general good clinical care. General principles and standards of care will be covered briefly with reference to other documents for further detail, including:

- *Rehabilitation following acquired brain injury: National clinical guidelines*, Royal College of Physicians (RCP), 2003 (www.rcplondon.ac.uk/publications/rehabilitation-following-acquired-brain-injury-0)
- *Medical rehabilitation in 2011 and beyond*, RCP[80]
- The National Service Framework (NSF) for Long Term Conditions[81]
- Standards for Rehabilitation Services, mapped on to the NSF for Long Term Conditions, British Society of Rehabilitation Medicine (BSRM), 2009[82]
- *Specialist neuro-rehabilitation services: Providing for patients with complex rehabilitation needs*, BSRM, 2010[83]
- *Specialist nursing home care for people with complex neurological disability: Guidance to best practice*, BSRM, 2013[84]
- *Specialist rehabilitation in the trauma pathway: BSRM core standards*. BSRM, 2013.[85]

2 Pathway of care

The care pathway for patients with PDOC is outlined in Fig 3.1. The diagram illustrates the principles of care but all steps of the pathway will not necessarily apply in every case.

Acute care

Many patients who enter a state of PDOC will be under the care of a team that may rarely if ever be confronted with the problems associated with prolonged coma, VS or MCS. They will not have any specialist knowledge, and will not have specialist skills in management of complex neurological disability.

An early priority is assessment by a specialist in neurology or neurorehabilitation who has expertise in management of these complex patients:

- to confirm the causation of DOC and identify any potentially reversible contributing factors
- to identify whether the primary neurological pathways are intact, and advise on appropriate investigation in the case of any doubt (see Section 2).

Although the principal role of the specialist neurorehabilitation team comes into play in the post-acute stage, the team should be involved from an early stage to support acute care clinicians in any of the task areas listed in Box 3.1, as they are needed while the patient remains in the acute care setting.

Within the major trauma pathway, a rehabilitation prescription is required within 96 hours (or 4 calendar days) of injury.[79] For patients with complex needs (which includes patients in coma or PDOC following traumatic brain injury) a specialist rehabilitation prescription is required, drawn up by a consultant in rehabilitation medicine.[85] As well as supporting their management in the acute stages of care, the specialist rehabilitation prescription should assist in directing patients down the appropriate pathway of care.

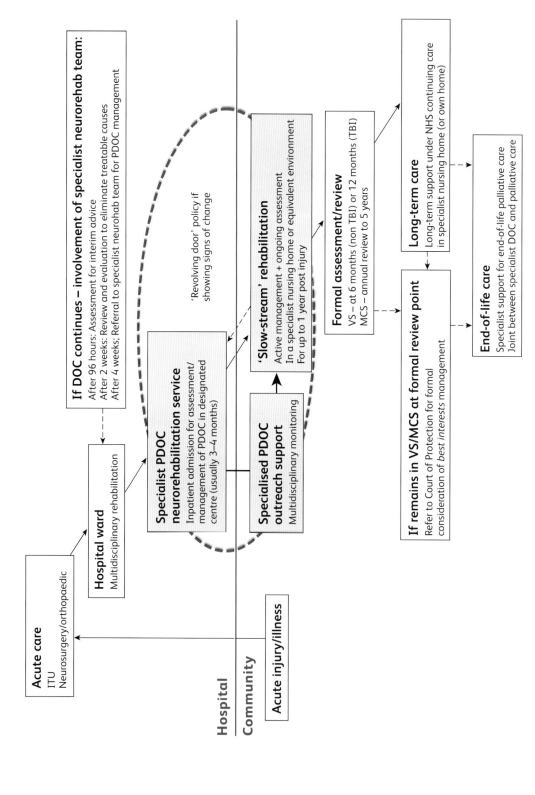

Fig 3.1. The care pathway for patients with PDOC. ITU = intensive therapy unit.

Post-acute care – early proactive management

It is rarely appropriate simply to repatriate patients with DOC to a general ward setting. As in every other part of healthcare, it is important that a patient should be managed by a clinical team and service with the appropriate knowledge and skills. The most appropriate specialist service to be involved after the acute phase is the neurological rehabilitation service led by a consultant in rehabilitation medicine with experience in management of PDOC.[80] Key roles of the specialist multidisciplinary neurorehabilitation team are listed in Box 3.1.

(Electronic annex 3a at www.rcplondon.ac.uk/pdoc lays out further details of clinical management of people in PDOC.)

Box 3.1. Early proactive managementy of patients with DOC.

The general management of patients with PDOC should follow the national clinical guidelines: *Rehabilitation following acquired brain injury* (www.rcplondon.ac.uk/publications/rehabilitation-following-acquired-brain-injury-0).

The multidisciplinary goal-orientated programme of care should include:
1 A 24-hour programme of care including:
 - airway management, including tracheostomy care, management of secretions, ventilatory support if required
 - enteral nutrition and hydration per gastrostomy (or jejunostomy if gastric stasis or oesophageal reflux are problematic) – with adequate nutritional support to meet dietary requirements, including enhanced calorie intake in the case of a hyper-catabolic state
 - management of oral reflexes (eg bite reflex, teeth-grinding etc)
 - a suitable bowel and bladder management programme
 - suitable precautions to avoid pressure ulceration, including risk assessment, special mattress etc
 - positioning/stretching to manage tone and avoid contractures, maintain skin integrity
 - supportive seating to offer a range of positions and allow assessment in a sitting position.

2 Medical management of any complications arising from severe brain injury including:
 - further investigations to determine the cause of brain injury and exclude complications, eg hydrocephalus, diabetes insipidus and other endocrine disturbance, seizures, visual and hearing impairments
 - management of sequelae including autonomic dysfunction ('sympathetic storming' or 'paroxysmal sympathetic hyperactivity'), pain, spasticity, intercurrent infections, thromboprophylaxis etc
 - medical surgical management of any comorbidities (eg fractures, blood pressure control).

Specific requirements for patients with PDOC include the following:
 - Registration of the person on the national clinical database (see Section 2)
 - Detailed clinical assessment of the level of interaction and responsiveness, which should take place throughout this period.
 - A formal structured assessment of the level of responsiveness using one of more of the recommended tools in Section 2, which should be performed once their medical condition has stabilised.

continued

Box 3.1. *continued*

- Information given to the family regarding diagnosis and expected prognosis, so far as this can be determined, with advice about possible future care and decision-making.
- Formal *best interests* meetings, which should be undertaken as required and involving the family (and/or other representatives, including Health and Welfare Lasting Power of Attorney (LPA), Welfare Deputy or Independent Mental Capacity Advocate (IMCA) as appointed) to address:
 - decisions regarding the appropriateness of resuscitation in the event of a cardiorespiratory arrest
 - any other key decisions regarding treatment and care, including life-sustaining measures (such as antibiotics), long-term care arrangements etc.
- Early discharge planning, including a formal meeting with the family (and/or other representatives) and healthcare commissioners, to discuss place of care and to start to put in place the appropriate arrangements for funding (usually through an application for NHS Continuing Care).

As most neurorehabilitation services do not have sufficient experience/throughput to manage patients with PDOC, the GDG recommends that there should be a small number of designated PDOC centres to build up critical mass. However, these should have outreach facilities to support ongoing monitoring/assessment of patients closer to their own home (eg in local rehabilitation units or specialist nursing home facilities).

Medium-term care

Initial assessment period

The patient should remain under the care of the specialist neurological rehabilitation service until the management recommended above has been completed. Depending on how long it takes to stabilise the patient's medical condition, and then perform the appropriate assessments of responsiveness and set up the care programme, this will usually mean that a patient remains in the acute/post-acute rehabilitation setting for 2–4 months, but on occasion up to 6 months.

A priority goal for the initial admission is often to support families in coming to terms with catastrophic brain injury and the establishment of realistic expectations. In highly distressing circumstances, their rate of adjustment is often another key factor to determine length of stay. Family members often benefit from the opportunity to meet and network with other families who are facing a similar set of problems.

Slow-stream rehabilitation

Patients remaining in VS or MCS are not in a position to participate in formal goal-orientated rehabilitation. Once their medical condition is stabilised, and a detailed clinical assessment of their needs has been completed, they will usually require a period of active management and ongoing assessment until either they recover sufficiently to benefit from a transfer to a specialist rehabilitation unit or it becomes clear that they are likely to remain in VS or MCS – usually 6 months to 1 year post injury.

Although families are often understandably keen for the patient to come home as soon as possible, it is rarely possible to provide the level of nursing care and expertise that is required at this stage in the context of the home environment. Placement in a formal care setting is usually required on either an interim or permanent basis.

It is essential that the chosen interim placement has the appropriate staffing expertise and facilities to manage patients in VS/MCS. This includes the provision of:

- an appropriate maintenance therapy programme to manage their physical disability
- an appropriate environment to provide controlled stimulation and encouragement for interaction
- ongoing monitoring of their level of responsiveness.

Electronic annex 2c provides specific advice for care staff on optimising conditions for interaction; see www.rcplondon.ac.uk/pdoc.

Placement will usually be a slow-stream rehabilitation environment or an appropriate specialist nursing home that caters specifically for the needs of adults with complex neurological disability. Standards for specialist nursing homes have recently been published by the British Society of Rehabilitation Medicine.[84]

Currently these specialist facilities are relatively thinly spread in the UK. A number of factors may influence the choice of facility including:

- whether it is anticipated to be a short- or long-term placement
- geographic proximity to family/other visitors
- the patient's specific needs for skills/facilities/equipment, which may be available in one setting but not another.

If the family is closely involved, ease of access for family visiting is often the key factor to govern choice of placement. Depending on the circumstances, however, families are often willing to travel quite long distances to ensure that the patient receives the best quality care.

- Families should be involved in discussions regarding suitable placement options and their preferences should be taken into account.
- The final choice of placement will take into account the wishes of the family, but ultimately be determined by the clinical needs of the patient on the basis of their best interests.
- Non-specialist nursing homes should be considered only if they can demonstrate that they can meet the needs of the patient and, at the same time, offer an advantage in proximity to the family. They should not be chosen simply because they are a cheaper option.

If anyone has been officially appointed as the patient's Welfare LPA or Deputy and their authority covers placement issues, it is essential that they are involved in any *best interests* meeting to decide place of care. If there is no family or they are deemed 'inappropriate to consult', then an IMCA must be instructed to represent the person. The report they are required to provide will be part of the *best interests* decision.

Funding for slow-stream rehabilitation

Funding for care of patients in VS or MCS should always be the responsibility of the NHS and should not be subject to means testing. All patients in PDOC should automatically meet the criteria for NHS Continuing Care.

Commissioners should note that the care package for this period of active management and ongoing assessment must include an appropriate maintenance therapy and stimulation programme, including:

- physical care – spasticity management, prevention of contractures etc
- review of long-term enteral feeding, swallowing therapy
- an appropriate programme of stimulation and opportunities for involvement in social activities
- training for staff to use tools, such as the Wessex Head Injury Matrix (WHIM), as a framework to record any observed responses
- where necessary, support for communication and interaction, including the provision of appropriate communication or environmental control aids and training for care staff to provide opportunities for interaction.

Ongoing surveillance and monitoring

The overall responsibility for holistic patient care for patients in a non-hospital setting lies primarily with the patient's GP. However, there should be a nominated consultant in neurorehabilitation or neurology, responsible for overseeing the review process, and providing advice as necessary to support the family local care team.

Patients in continuing VS or MCS should remain under surveillance by a specialist neurorehabilitation team, to provide specialist advice as necessary and monitor for any significant change in the level of responsiveness or clinical condition (see Section 2).

Once the specialist neurological rehabilitation service judges that, on the balance of probabilities, the patient will remain in a vegetative state, the family should be:

- informed of this and invited to discuss the patient's prior expressed values, beliefs, wishes and feelings in relation to such a possible outcome
- informed that withdrawal of life-sustaining treatment may be advised if the patient remains unaware, *and*
- given ongoing opportunities to discuss withdrawal of life-sustaining treatment, including the practical, legal and emotional aspects.

Not all patients travel in linear fashion down the care pathway. Early discharge from post-acute rehabilitation relies on appropriate facilities being available in the community, and also the ability to operate a 'revolving door' policy to offer further planned or unplanned admission, in accordance with patient needs.

Reasons for requiring readmission to the specialist neurorehabilitation unit may include:

- improvement in the patient's level of responsiveness to an extent where he or she would benefit from a specialist goal-orientated rehabilitation programme
- the placement proves to be unable to meet the care needs satisfactorily, requiring care needs to be redefined and a suitable alternative found

- a specific problem that requires admission for disability management (eg severe spasticity, marked postural difficulties, skin pressure ulceration, decannulation of tracheostomy) or medical/surgical management
- the patient reaches a critical time point for diagnosis and decision-making and requires a short admission to assess formally the level of awareness and to confirm permanence (or otherwise).

In the longer-term stages of care, all patients in PDOC should have an annual review by an appropriately skilled assessor, to review or reconfirm their diagnosis, until either they emerge from PDOC or they die. At a minimum, this should include application of the WHIM or the CRS-R, and data should be passed to the national register, as and when this has been developed (see Section 2).

Long-term care

Long-term care should be provided in an appropriate setting, which may be in the patient's own home with family, but is more usually arranged in a nursing home setting; living alone with a care team is not appropriate.

Long-term nursing home care should be delivered in a setting that has appropriately skilled staff to manage the needs of patients with PDOC, including:

a management of physical disability, including maintenance therapy for tone/postural management (including management of spasticity and prevention of contractures/pressure sores etc), medical surveillance etc
b enteral feed and tracheostomy management
c appropriate stimulation and ongoing assessment of behavioural responses
d support for families.

If the nursing home does not have its own therapy team, arrangements should be in place to provide a maintenance therapy programme through visits from the local community rehabilitation team or an alternative spot-purchasing arrangement.

As for interim care, long-term placement should take account of the needs of the family and ease of access for visiting – especially in circumstances where the patient responds best to family members and appears to gain positive life experience from family visits. The longer the time since injury, the less likely it is that the patient will emerge, so at this stage the emphasis is more on maintaining quality of life than preserving function towards the expectation of future recovery.

Long-term care in the home

As noted above, families are often keen for the patient to be placed at home, but often without any clear understanding of the enormity of the task of caring for them. Patients with PDOC have very intensive and specialist care requirements and it is rarely feasible or practical to provide care in the home setting unless one or more family members are dedicated to providing the role of lead carer. On the other hand, a small number of patients react so positively to family members and home life that care at home is agreed by all parties to be the best option.

Caring for an individual who has very limited ability to interact is a challenging task for non-family carers, and there are often practical difficulties including recruitment and retention of suitably trained care staff.

In the majority of cases, the patient's lack of awareness limits the extent of positive experience that may arise from being at home. Inevitably the household tends to revolve around their needs, which may be to the detriment of others (for example, children) in the home setting.

In many cases, a much better solution may be to provide the majority of care in a nursing home setting, but with the opportunity to spend short periods (usually daytime visits) at home. When planning these arrangements, factors to consider are:
- travelling distance to and from the home and the length of time the patient can sit comfortably in a wheelchair, risk of pressure sores etc
- access into the home, and to facilities within the home, in case of episodes of incontinence or if an overnight stay is planned.

As in all other areas of care, the decision to arrange home care or home visits must be taken in the patient's best interest, based on the balance of benefits and risks.

Short-term readmission for intercurrent medical/surgical conditions

From time to time patients in VS/MCS may require short-term acute hospital admission for intercurrent illness or planned procedures. All such interventions should be undertaken with due regard to *best interests* decision-making and planned ceiling of care.

Staff should follow the recommendations laid out in Quality Requirement 11 of the National Service Framework (NSF) for Long Term neurological Conditions, to ensure that patients' neurological needs are met while in hospital. This will require liaison with their usual neurological care team, and the involvement of any family carers who are likely to be more familiar with their individual care needs. For some more complex elective procedures, it may be appropriate to arrange short-term admission to the specialist neurorehabilitation services (as opposed to a general ward where staff are unlikely to be familiar with their needs). This, however, will depend on the patient's needs and ease of access to the required acute services from within the specialist neurorehabilitation service.

3 Support for families

People who remain unresponsive present great emotional and social challenge to others – especially to family members, but to others as well.
- At one level they seem 'alive' because they wake and go to sleep; they may move and make noises spontaneously; and they often react to external stimuli.
- But, at the same time, they do not initiate any communication or social interaction and they appear unreactive to anything meaningful.
- They may also appear to be in pain or distress at times.

This unusual state is stressful for many reasons:
- It challenges our normal understanding of people and their behaviour.
- The family cannot grieve their loss fully, yet they cannot expect a 'good outcome' (ie either a return to the pre-existing state or at least a return to some kind of demonstrable contentedness).
- They sometimes receive differing explanations and prognosis from the various medical and clinical teams involved.
- For some families, the state of existence of their loved one may be in contradiction to that person's prior expressed views on how they would want to live. Their inability to protect their loved one from this unwanted outcome can be a source of guilt, anger and distress.

Many families will have been informed during the early acute stage of injury that the patient is unlikely to survive. Once the patient has survived, apparently against all odds, miracles may seem not only possible but likely, and family members may see their loved one as a 'fighter' with a determination to recover which will overcome physiological obstacles. They may therefore have high expectations for full recovery, and be inclined to disbelieve less optimistic prognostication.[86] In addition, there is often genuine uncertainty about the patient's condition and prognosis until evaluation is complete, and it is important to keep open lines of communication and a free exchange of information as evaluation progresses and the picture clarifies.

It is critical to provide consistent support and information for the family and relatives and/or other people with strong emotional attachments, and to involve them as closely as possible in decisions made in the patient's best interests (see Section 4).

All families should be offered support to encompass, as needed:
- information, including:
 - explanation of the clinical state
 - the prognosis, available treatments, necessary investigations
 - proposed management plan
- emotional support
- practical support, eg assistance with managing finances, housing, medico-legal issues etc.

Families should be supported to engage actively in the care programme if they so wish, and provided with tasks/activities that they can undertake with the patient, such as gentle massage/stretching, stimulating activities etc.

They should be offered counselling and support at a stage when they are ready to receive this. However, they are often not ready to engage with this in the early stages, so the offer may need to be repeated. It is also important that such support is provided by professionals with an understanding of PDOC and the different ways that people react to the diagnosis and its implications for the whole family.

Family members often gain support for being in contact with others who are or have been in a similar position. The management of patients with PDOC in centres with a critical mass of patients in the condition can be very positive. In addition, groups such as BIG, the Brain Injury Group (www.braininjurygroup. org.uk/Pages/default.aspx), which was developed as a support group for people who have loved ones with devastating brain injuries, can also provide welcome peer-group support for families.

Section 3 Management and long-term care: Summary of recommendations

	Recommendation	Grade
3.1	**Early referral for advice on disability management** As with all patients with severe brain injury, patients who continue to have a DOC after 96 hours (4 calendar days) should be assessed by a specialist neurorehabilitation team for interim advice on management of neurological disability.	E1/2
3.2	**Specialist neurological evaluation** 1 Every patient whose Glasgow Coma Scale (GCS) score remains ≤10/15 2 weeks after onset of coma should have a specialist neurological evaluation within 3 weeks of onset to: a confirm the causation of DOC and identify any potentially reversible contributing factors b identify whether the primary neurological pathways are intact, and advise on appropriate investigation in the case of any doubt.	E1/2
3.3	**Referral for specialist management by the neurorehabilitation team** 1 Every patient whose GCS remains at ≤10/15 at 4 weeks should have active and continuing involvement of a specialist neurological rehabilitation service, led by a consultant in rehabilitation medicine.	E1/2
3.4	**Transfer to post-acute specialist care** It is not appropriate simply to repatriate patients with PDOC to a general ward setting. 1 As soon as the patient's medical condition allows, patients with continuing PDOC should be transferred to the care of a specialist neurorehabilitation team – preferably to a unit specialising in the assessment/management of prolonged disorders of consciousness.	E1/2
3.5	**Exchange of information with the family** There should be regular contact between the treating team and the family to provide support and 2-way exchange of information. 1 The family should be offered support to encompass, as needed: a information, including: • explanation of the clinical state and its prognosis • proposed management plan for investigation and treatment b emotional support c practical support, eg with managing finances, medico-legal issues etc. 2 Family members should also have the opportunity to be involved as closely as possible in decisions made in the patient's best interests (see below).	E1/2
3.6	**Management programme** The general management of patients with PDOC should follow *Rehabilitation following acquired brain injury: national clinical guidelines* (www.rcplondon.ac.uk/publications/rehabilitation-following-acquired-brain-injury-0). 1 The patient should have a coordinated programme of care delivered by a multidisciplinary team including: a a 24-hour programme of care as detailed in Section 3 including supportive seating to maximise potential for interaction b medical management of any complications arising from severe brain injury c formal assessment of the level of interaction and responsiveness as described in Section 2. 2 Formal *best interests* meetings undertaken as required and involving the family and other appointed patient representatives (eg Welfare Deputy or Independent Mental Capacity Advocate (IMCA)) to address: a decisions regarding the appropriateness of resuscitation in the event of a cardiorespiratory arrest b life-sustaining measures such as antibiotics etc.	E1/2

3 Early discharge planning, including a formal meeting with the family and healthcare commissioners to discuss place of care, and start to put in place the appropriate arrangements for funding.

3.7 Length of programme in specialist assessment centre
E1/2
1 The length of time in the specialist centre should depend on the individual's needs, and is dictated by the time taken to complete the tasks in recommendation 3.6 above
2 The rate of adjustment of the family is often another key factor.
3 In most cases 3–4 months should be sufficient, but occasionally up to 6 months.

3.8 Medium-term care
E1/2
Patients in VS or MCS are not in a position to participate in formal goal-orientated rehabilitation.

1 Once their medical condition has stabilised and a detailed clinical assessment of their needs has been completed:
 a Patients should be managed in a placement outside of the acute/post-acute setting, until it becomes clear that they are likely to remain in VS or MCS – usually 6 months–1 year post injury.
 b This will usually be a slow-stream rehabilitation environment or an appropriate specialist nursing home, which caters specifically for the needs of adults with complex neurological disability.

3.9 Funding for slow-stream and long-term care
E1/2
1 Funding for care of patients in VS or MCS should always be the responsibility of the NHS and should not be subject to means testing.
2 All patients in PDOC should automatically meet the criteria for 100% NHS Continuing Care.

3.10 Requirements of a 'slow-stream' placement
E1/2
1 The specialist nursing home must have the appropriate staffing expertise, equipment and facilities to manage patients with complex neurological disability, specifically those in VS/MCS.
2 This includes the provision of:
 a an appropriate maintenance therapy programme to manage their physical disability
 b an appropriate environment to provide controlled stimulation and encouragement for interaction
 c ongoing monitoring of their level of responsiveness.
(NB: see below and also *Specialist nursing home care for people with complex neurological disability: guidance to best practice*, BSRM, 2013).[84]

3.11 Family involvement in choice of placement
E1/2
If the family is closely involved, ease of access for family visiting is often a key factor governing the choice of placement.

1 Families should be involved as closely as possible in discussions regarding suitable placement options and their preferences should be taken into account. This is not only important for caring reasons, but is a key part of making *best interests* decisions, which are a legal requirement as defined by the Mental Capacity Act 2005.
2 The final choice of placement will take into account the wishes of the family, but ultimately be determined by the clinical needs of the patient on the basis of their best interests.
3 Non-specialist nursing home options should be considered only if they can demonstrate that they meet the needs of the patients and, at the same time, offer an advantage in proximity to family. They should not be chosen simply because they are a cheaper option.
4 If anyone has been officially appointed as the patient's Welfare LPA or Deputy and their authority covers placement issues, it is essential that they are involved in any *best interests* meeting to decide place of care.
5 If there is no family or they are deemed 'inappropriate to consult' then an IMCA must be instructed to represent the person and the report they are required to provide will be part of the *best interests* decision.

3.12 Longer-term care

E1/2

1 Longer-term care should be provided in an appropriate setting, which will usually be a nursing home setting.

 a Occasionally patients with PDOC may be managed in their own home, but it should be noted that they have very intensive and specialist care requirements. It is rarely feasible or practical to provide care in the home setting unless one or more family members is dedicated to providing the role of lead carer.

2 Nursing home care should be delivered in a setting which has appropriately skilled staff to manage the needs of patients with PDOC, including management of:

 a physical disability, including maintenance therapy for tone/postural management (including management of spasticity and prevention of contractures/pressure sores etc), medical surveillance etc

 b enteral feed and tracheostomy management

 c appropriate stimulation and ongoing assessment of behavioural responses

 d support for families.

3 If the nursing home does not have its own therapy team, arrangements should be in place to provide a funded maintenance therapy programme through visits from the local community rehabilitation team or an alternative arrangement.

4 Long-term placement should take account the needs of the family and ease of access for visiting – especially in circumstances where the patient responds best to family members and appears to gain positive life experience from family visits.

3.13 Review and monitoring

E1/2
RA

1 Patients in VS or MCS should remain under surveillance by a specialist neurorehabilitation team, to provide specialist advice as necessary and monitor for any significant change in the level of responsiveness or clinical condition.

2 All patients in PDOC should have an annual review by an appropriately skilled assessor, to review or re-confirm their diagnosis.

3 At a minimum, this should include application of the WHIM or the CRS, and data should be passed to the national register, as and when this develops.

3.14 Supporting families

E1/2

1 Families should be supported to be actively engaged in the care programme, and be provided with tasks/activities that they can undertake with the patient, such as gentle massage/stretching, stimulating activities etc.

2 Families of patients with PDOC should be offered counselling and support at a stage when they are ready to receive this.

3 Families are often not ready to engage with this support in the early stages, so the offer may need to be repeated.

3.15 Poor prognosis for recovery

E1/2

1 Once the specialist neurological rehabilitation service judges on balance of probability that the patient will remain in a vegetative state, the family should be:

 a informed of this and invited to discuss the patient's prior expressed values, beliefs, wishes and feelings in relation to such a possible outcome

 b informed that withdrawal of active treatment may be advised if the patient remains unaware, *and*

 c given ongoing opportunities to discuss withdrawal of active treatment, including the practical, legal and emotional aspects.

Section 4
Ethical and medico-legal issues

1 Introduction

All patients who possess mental capacity to make decisions about their treatment have the right to express their own choices, including the freedom to refuse treatments.

By contrast, patients in PDOC lack the mental capacity to make decisions about their own care and treatments. Their wishes may not be known directly by those responsible for their care, unless they are recorded in writing in a valid and applicable Advance Decision to Refuse Treatment. This raises the following questions:

- How do we decide what people want when they cannot tell us?
- How do we assess what is in their best interests?
- Who is responsible for making these decisions?
- Does someone in MCS or VS have interests, and if so, what are they?

Ethical principles

Ethics underpins the law but also goes beyond it, guiding action where the law may be silent. A detailed exploration of the complex ethical issues involved in this context is beyond the scope of this document, and more detailed accounts of the relevant ethical arguments can be found elsewhere including in the RCP's guide to oral feeding.[87]

Briefly, the theory of 'consequentialism' states that the outcome of our actions determines their morality, thus the right action is the one that will result in the best consequences. In contrast, 'deontology' suggests that certain sorts of actions are wrong in themselves, independent of the result of such actions.

Both these ethical theories are concerned with how we treat people. It is therefore important to have some understanding of whether and how a patient with a persisting disorder of consciousness could be considered a person. Personhood is extremely difficult to define and can be approached from a variety of perspectives including biological, relational, religious and cognitive. In many definitions of personhood, autonomy and self-awareness are critical, but others take a somatic approach arguing that persons are identical with their physical bodies; yet others would argue that personal identity is constituted in and sustained through our relationships with others.

The ethical frameworks described above may be simplified into four operational principles that underlie the day-to-day practice of the doctor. They are:

1 the responsibility to preserve life, restore health and relieve suffering
2 the responsibility to avoid harm
3 respecting the patient's right to autonomy
4 managing the patient's needs in relation to external factors, which may include the needs of others and fair distribution of resources.

These four principles may conflict with one another and are often inadequate to deal with complex situations such as those posed by PDOC.

Where decisions are difficult, the *process* of making that decision becomes more important. Therefore, when deciding whether to adopt a certain treatment strategy for a patient who is unable to make the decision him/herself, the clinicians must weigh up the balance of benefits and harms of the treatment in question – not only in the medical context but in the wider social and personal context of the individual, so far as this is known or can be gathered. It is important to remember that avoiding harm may include stopping or withdrawing treatment – or not starting the treatment in the first place.

Some decisions may ultimately involve reference to the Court of Protection, although most can be resolved at a clinical level or on the basis of *best interests* decision-making.

2 The Mental Capacity Act 2005

The Mental Capacity Act 2005 (MCA)[88] is a statute in force in England and Wales. It sets out a legal framework for determining mental capacity and making decisions on behalf of those over 16 years old who lack the capacity to decide for themselves.

The equivalent legislation in Scotland is the Adults with Incapacity (Scotland) Act 2005. A Mental Capacity Act for Northern Ireland is planned, but currently decisions take place under the common law. These guidelines will not consider Scottish or Northern Irish legislation and readers are recommended to seek expert legal advice in those devolved parts of the UK about legal matters, but the general clinical principles will still apply.

Box 4.1 sets out the key features of the MCA. Section 1 of the MCA contains five statutory principles, which are designed to protect people who lack capacity to make particular decisions, but also to maximise their ability to make decisions, or to participate in the decision-making process, so far as they are able to do so. It also gives clear guidance on determining *best interests* and the processes that should be followed when making healthcare decisions on behalf of a patient.

The MCA also sets out the legal test of mental capacity, and introduces a series of provisions to support *best interests* decision-making (including the appointment of an Independent Mental Capacity Advocate (IMCA) in some cases). It also makes provision to allow people to plan ahead for decisions regarding medical care and treatment, through Advance Decisions to Refuse Treatment, or making a Lasting Power of Attorney. The Court may also appoint a Welfare Deputy after a person has lost the requisite mental capacity.

Box 4.1. Key features of the Mental Capacity Act (MCA) 2005

Section 1 of the MCA contains five statutory principles designed to protect people who lack capacity to make decisions:

1 A person must be assumed to have capacity unless it is established that he/she lacks capacity.
2 A person is not to be treated as unable to make a decision unless all practicable steps to help him/her to do so have been taken without success.
3 A person is not to be treated as unable to make a decision merely because he/she makes an unwise decision.
4 An act done, or decision made, for or on behalf of a person who lacks capacity must be on the basis of a valid and applicable Advance Decision or must be done, or made in his/her best interests.
5 Before the act is done, or the decision is made, regard must be had to whether the purpose for which it is needed can be as effectively achieved in a way that is less restrictive of the person's rights and freedom of action.

The MCA also:
- makes it a criminal offence wilfully to neglect someone who lacks capacity (MCA s44)
- makes provision for people to plan ahead for a time when they may need support (MCA s24)
- confirms the status of **Advance Decisions to Refuse Treatment** (MCA s24)
- introduces an **Independent Mental Capacity Advocate** (**IMCA**) service to provide help for people who have no intimate support network (MCA s35)
- provides for the ability to create a **Lasting Power of Attorney** (**LPA**) which allows people aged 18 or above (MCA s9(2)(c)) to make appropriate arrangements for family members or trusted friends to be authorised to make decisions on their behalf. This can be with respect not only to property and financial affairs, but also to health and welfare matters through the appointment of a Health and Welfare LPA (MCA s9).
- provides for the Court to appoint a personal Welfare Deputy (MCA s16/17).

Lack of mental capacity
Capacity is *specific to the decision to be made* at the time it is made.
The MCA contains a two-part test of capacity (MCA s2 and s3):
(i) **The diagnostic test:**
 Is there an impairment of, or disturbance in the functioning of, the person's mind or brain?
(ii) **The functional test:**
 If so, does the identified impairment or disturbance cause the person to be unable to:
 - understand information relevant to the decision
 - retain that information
 - use or weigh that information as part of the process of making the decision
 - communicate the decision (by any means).

Failure *on any one* of these criteria means that the patient lacks capacity.

Disputes in relation to matters that fall within the MCA are adjudicated by the Court of Protection, whose judges are empowered to make *best interests* decisions (in respect of a person who lacks capacity to make the relevant decision), and to declare that a course of action by a health professional will be lawful (s16).

The Office of the Public Guardian is the administrative arm of the Court of Protection, and the Official Solicitor can be appointed to represent a person lacking capacity as a 'litigation friend' in court.

Mental capacity in patients with PDOC

The MCA requires a two-stage test of mental capacity, which should be made separately in relation to different decisions as laid out in Box 4.1.

By definition, a person in PDOC will lack the mental capacity to make decisions regarding their welfare and/or treatment. Nevertheless, the lack of mental capacity should be formally documented in the patient records in accordance with the MCA test of capacity along the following lines:

> *'X lacks the mental capacity to make decisions regarding his/her care and treatment due to severe brain injury, and because he/she lacks the ability to understand and retain information, to weigh it up in order to reach a decision, or to communicate a decision.'*

In the absence of a valid and applicable Advance Decision to Refuse Treatment, all decisions regarding care and treatment must therefore be made for patients with PDOC on the basis of their best interests. When determining *best interests*, the decision-maker must take account of the views of anyone engaged in caring for the person or interested in his welfare and the reasonably ascertainable past wishes of the patient.

3 Provisions within the Act to support decision-making for patients who lack capacity

Health and Welfare Lasting Power of Attorney

Sections 9–11 of the MCA 2005 make provision for Lasting Power of Attorney (LPA) arrangements, and lay out the rules of appointment and restrictions to the role of a 'Health and Welfare LPA' donee (referred to hereafter as a 'Welfare LPA').*

A person who has capacity may use Sections 9–11 to appoint one or more people as their Welfare LPA(s) to make decisions about health and welfare on their behalf when the person him/herself no longer has capacity.

If more than one person is appointed, the LPA may specify whether they are to act:
- 'jointly' (together) or
- 'jointly and severally' (all *or* any one of them may make a decision) or
- jointly in respect of some matters and severally in respect of others.

*Technically within the MCA, the term 'LPA' refers to the document that is drawn up to confer decision-making authority, rather than the donee themselves. However, in clinical settings the term 'Welfare LPA' is a widely understood and used shorthand term for the 'donee of the Health and Welfare LPA', and is the sense in which it is used here.

Where this is not specified, the LPA is to be assumed to appoint them to act jointly. The LPA(s) have a duty to decide always on the basis of the patient's best interests.

The Welfare LPA's authority is restricted to the extent that:
- it cannot override an Advance Decision to Refuse Treatment (ADRT) that is valid and applicable
- it does extend to giving or refusing consent to medical examination or treatment
- it may authorise the giving or refusing of consent to life-sustaining treatment, but only if the LPA document contains express provision to that effect.

Therefore, where the patient has a Welfare LPA, the treating team should ask to see a copy of the LPA document in order to understand the terms of the authority and which individuals have authority for what decisions.

Court-appointed Welfare Deputy

Under Section 16 of the MCA, a Welfare Deputy may be appointed by the Court of Protection to make treatment decisions in respect of which a patient lacks capacity (s19).
- The extent of the Deputy's powers will be delineated by the Court on appointment.
- Their appointment may relate to just one single treatment decision or to a more general power that covers a wide range of treatment and welfare issues.
- A Welfare Deputy must always act in the patient's best interests (s20(6)).
- A Deputy may *never* refuse consent to the carrying out or continuation of life-sustaining treatment (s20(5)).

If a Welfare Deputy has been appointed to make treatment decisions on behalf of a person who lacks capacity, then it is the Deputy (rather than the healthcare professional) who makes the treatment decision, so long as it complies with the terms of their appointment.[89] The treating team should ask to see a copy of any court order that appoints the Welfare Deputy, in order to confirm and understand the scope of the Deputy's authority. The Deputy's powers extend to deciding whether the treatment(s) considered by the healthcare professionals to be an option should be given or not. The Deputy does not decide what the options are.

Independent Mental Capacity Advocate

A patient who lacks capacity, and does not have 'appropriate' family or friends to advocate on their behalf, has the right to an Independent Mental Capacity Advocate (IMCA) when certain decisions are being made.

IMCAs are statutory advocates, which means that their involvement is required for certain decisions.

An IMCA must be instructed where a patient is:
- aged over 16 *and*
- lacks capacity to make the specific treatment or accommodation decision *and*
- there is nobody 'appropriate to consult' about the decision.

IMCAs are independent of the NHS and local authority and are there to support the person when a *best interests* decision is being made on their behalf.

Advocates normally help people to express their views and wishes, secure their rights, access information and be involved in decisions that are being made. Patients in PDOC are unable to be supported to express their views, but the IMCA still has a crucial role to play – which may include:

- helping to collect and represent the person's prior expressed values and beliefs
- ascertaining proposed courses of action
- gathering the views of professionals and paid workers providing care or treatment and of anybody else who can give information about the wishes and feelings, beliefs or values of the person
- accessing any other information they think will be necessary
- considering whether getting another medical opinion would help the person who lacks capacity.

The IMCA then prepares a report, which must be taken into consideration in the determination of the patient's best interests.

4 Process to establish 'best interests'

Best interests are **not** restricted purely to medical considerations, nor do they necessarily mean the prolongation of life.

The MCA and its code of practice emphasise:

- that a broad range of matters are taken into account when deciding on a patient's best interests, including their known views on medical treatments, the acceptance of risk etc.
- the need to follow a proper process, and to document the process and the grounds for the decisions made
- that being a family member does not, of itself, impart a right to make any treatment decision on behalf of an adult lacking capacity (save those formally appointed as a Welfare LPA or Deputy, who can then make healthcare decisions in prescribed circumstances).

Evaluation of best interests is a holistic exercise, and is best addressed through a team-based approach.

Section 4 of the MCA lays out practical guidance and a checklist of points to consider when determining best interests, which are summarised in Box 4.2 according to the MCA code of practice.

Box 4.2. Practical points to consider when determining best interests

A person trying to work out the best interests of a person who lacks capacity to make a particular decision should do the following:

1 **Encourage participation** – *so far as is possible*, to support the person to participate in making the decision.
2 **Identify all relevant circumstances** – that the person would take into account if they were making the decision or acting for themselves, taking into account the benefits and harms of treatment.

continued

Box 4.2. *continued*

3 **Find out the person's views** including:
 - their past and present wishes and feelings – however expressed
 - any beliefs and values (eg religious, cultural, moral or political) that may influence the decision
 - any other factors the person might consider if making the decision for themselves.

4 **Avoid discrimination** – not make assumptions about someone's best interests simply on the basis of the person's age, appearance, condition or behaviour.

5 **Assess whether the person might regain capacity** (eg after receiving medical treatment). If so, can the decision wait until then?

6 **If the decision concerns life-sustaining treatment** – not be motivated in any way by a desire to bring about the person's death or to prolong their life. They should not make assumptions about the person's quality of life. But consideration of end-of-life care should be included in *best interests* discussions.

7 **Consult others** – so far as it is practical and appropriate to do so. In particular, try to consult:
 - anyone previously named by the person as someone to be consulted either on the decision in question or on similar issues
 - anyone engaged in caring for the person or close relatives, friends or others who take an interest in the person's welfare
 - any Welfare LPA or court-appointed Welfare Deputy.
 Where there is no-one who fits into any of the above categories, an IMCA must be consulted for decisions about major medical treatment or where the person should live.

8 **Maintain privacy** – when consulting, remember that the person still has a right to keep their affairs private.

9 **Avoid restricting the person's rights** – consider whether there are options that may be less restrictive of the person's rights.

10 **Take all of this into account in weighing up the person's best interests.**

The decision-maker must be familiar with the *best interests* checklist and know that determining a person's best interests is not simply a 'clinical decision'. Instead it considers a range of factors, *including* taking into account the patient's prior expressed values and beliefs – eg what the patient would have wanted for themselves, for example, what treatments they would have consented to, or refused. This is where consultation with family and close friends is essential.

As the MCA *Code of practice* states: '*The person may have held strong views in the past which could have a bearing on the decision now to be made. All reasonable efforts must be made to find whether the person has expressed views in the past that will shape the decision to be made. This could have been through verbal communication, writing, behaviour or habits or recorded in any other way...*' (*Code of practice*, para 5.41)

It is important to manage *best interests* meetings to ensure that such information is both fully ascertained and fully incorporated into *best interests* decision-making.

The role of the healthcare team

The healthcare team has a responsibility to act at all times in the best interests of a person who lacks capacity.

When a person no longer has the mental capacity to participate in decision-making, then the healthcare team can and should make healthcare decisions in accordance with the patient's best interests unless:

- there is a court-appointed Welfare Deputy or Welfare LPA whose power of authority covers the decision in question
- there is a valid and applicable Advance Decision to Refuse Treatment in place that covers the specific situation.

The clinical team must check as soon as possible whether any of these are in place. They should ask to see the relevant documentation in order to understand the extent of any Welfare LPA or Deputy's decision-making power.

Only in their absence does the treating clinician become the decision-maker – and then they have a duty to consult with family members in order to inform their *best interests* decisions.

(Electronic annex 4a provides an adapted *best interests* checklist for patients with PDOC; see www.rcplondon.ac.uk/pdoc.)

The role of the family

Although family members must be given the opportunity for involvement in decision-making regarding care and treatment, it is important to emphasise that, unless a family member has a relevant LPA or deputyship, the responsible senior clinician has ultimate responsibility for healthcare decision-making based on judgement of what is in the patient's best interests, taking into account what the patient would want if they could express a view.

The clinical team should identify carefully which people have a sufficiently close relationship to the patient to be considered as 'family' as defined in Section 1 of these guidelines. All family members should be asked about the person's previously expressed views, attitudes to healthcare etc as a preparation for and as part of establishing the patient's best interests.

Families and friends provide the only available insights into the patient's pre-morbid character, beliefs, and what their wishes might be about treatment and care decisions. Their role is therefore to provide information and help to formulate *best interests*. However, this is not easy.

- Some families report that they feel excluded from the decision-making process, while others report that staff put inappropriate pressure on them to offer opinions concerning life-changing decisions for which they lack knowledge.
- Sometimes families feel they are being asked 'to make an impossible decision', such as to allow a loved one to die, and they would rather any such decision were left to the clinicians.
- They may feel they are being asked to come to a 'consensus'.

Being clear about roles, rights and responsibilities and managing the relationships and communication between all concerned must therefore be a priority and subject to constant review. It should be made clear that a decision made in a person's *best interests* is not *necessarily* the same as the whole family being happy about a particular decision (for example, a family cannot easily be expected to say that they 'want' or 'are happy' to allow death).

Although clinical practice is that only one individual is identified as 'Next of Kin', there is no such legal concept. The MCA does not privilege any one relative's views above another, but requires that there is consultation with and account taken of the views of *anyone engaged in caring for the person or interested in his welfare*' (MCA s4(7)).

- Normal procedure is for all communication between the family and the treating team to be channelled through the named 'Next of Kin', which has advantages in consistency and economies of time. While this individual still has a key role as the primary recipient of information, the frame of communication often needs to be widened for *best interests* decisions, in order for the treating team to obtain a holistic picture of the patient's character and preferences
- Where there is disagreement between family members about what the patient would want, it is important for the treating team to document the various views and to record why a decision was considered to be in the person's best interests. This is especially important if the decision goes against the views of somebody who has been consulted during the decision-making process (*Code of practice*, paras 5.51–52).

Where family and/or friends are considered 'not appropriate to consult with', then an IMCA is appointed instead. Family and friends should be deemed 'appropriate to consult' unless there are reasons to dispute this. It is not acceptable for them to be judged 'not appropriate to consult' simply on the basis that they are not in agreement with the proposed *best interests* decision or because there is some conflict between family or friends and the decision-maker. The responsible body (NHS or local authority) should give the reasons for this and the rationale for involving an IMCA should also be given to the family.

(Electronic annex 4b at rcplondon.ac.uk/pdoc provides information about the role of family and friends in serious medical decision-making for people with VS or MCS.)

5 A summary of key roles in decision-making

It is important to be clear about terminology and the legal status of the different types of people who might be responsible for making decisions or whom the decision-maker might consult. A failure to distinguish clearly between these roles could leave a clinician in danger of treating without consent, or not giving treatment in the patient's best interests. It could exclude people from being consulted who should have been. It can also leave family members feeling responsible for decisions that are, in fact, not for them to enact.

Table 4.1 summarises the different non-clinical people who can, and should, be involved in decisions.

Table 4.1. Key terms for (non-clinical) people who might be involved in decision-making.

Term	Legal status for *best interests* decisions under the Mental Capacity Act
'Next of Kin'	There is no such legal concept or status, but the 'Next of Kin' is usually a relative or close friend who has been nominated by the patient (often some time in the past), through whom communication between the treating team and family is normally channelled.
'The family'	No decision-making power (unless also appointed as Welfare LPA or Deputy – see below). But those close to the patient must be consulted in any *best interests* decisions in order to ascertain the patient's prior values, beliefs etc. This could include friends. It is important not to assume who represents 'the family' and to think carefully about who to consult with (see MCA *Code of practice*).
Decision-maker	A person who is ultimately responsible for *best interests* decisions on behalf of a patient who lacks capacity. This is the Welfare LPA or Welfare Deputy if they exist, and their powers cover the issue in question. Otherwise it is the senior clinician with treating responsibility for the patient – usually the consultant.
Welfare LPA (appointed *before* loss of capacity)	The decision-maker for the patient under the specific terms of their Attorney appointment. *The Welfare LPA may have been given the authority to give/refuse consent to life sustaining treatment, but only if the LPA document contains express provision to that effect* (MCA s11(8)).
Court-appointed Welfare Deputy (appointed *after* loss of capacity)	The proxy decision-maker for the patient under the specific terms of their court order. The extent of their powers depends upon the terms of the court order appointing them. If a Deputy has been appointed to make treatment decisions, then that Deputy's consent, or withholding of consent to treatment, is binding on the healthcare professionals. *A Deputy may never refuse consent to life-sustaining treatment* (MCA s20(5)).
IMCA	The IMCA cannot make decisions, but they advocate for the patient. An IMCA must be consulted in the absence of appropriate family/friends/Deputy/Attorney, and they provide a report, which must be taken into account during *best interests* decision-making.

6 Practical arrangements for *best interests* decision-making

In the first few days and possibly weeks, the need for rapid decisions, coupled with clinical uncertainty concerning prognosis, may be such that the maintenance and prolongation of life is a predominant determining factor when weighing up a patient's best interests. Other guidelines cover implementation of the MCA in acute and critical care settings.[90]

Nevertheless, the healthcare team should establish as soon as possible whether there is an Advance Decision to Refuse Treatment, Welfare LPA or Welfare Deputy in place whose powers cover the relevant decisions. In the absence of these, the process of identifying key family members and obtaining information about the patient's likely wishes should start at an early stage.

By 4 weeks after onset of PDOC it will usually be possible for most of the relevant medical and social factors to have been explored and considered in determining the patient's best interests. A formal *best interests* decision meeting should normally be held at least within 4 weeks after the onset of PDOC, and on subsequent occasions when important decisions are to be made. Arrangements for formal *best interests* meetings are described in Box 4.3.

> ### Box 4.3. Arrangements for formal *best interests* meetings.
>
> Formal *best interests* meetings should be arranged with the family/close friends, the Welfare Deputy or Welfare LPA and IMCA (if one is in place).
>
> The following should be discussed and documented:
>
> 1 Any treatment decisions needed or likely to be needed within the foreseeable future should be identified and separated into:
> - *routine decisions unlikely to be altered* (eg simple symptomatic treatments)
> - *elective major decisions* with potential benefits or risks that affect survival and/or quality of life (eg elective placement of a percutaneous endoscopic gastrostomy (PEG) tube; operation to treat another injury)
> - *immediate major decisions* that may arise, in particular attempted resuscitation and the treatment of life-threatening events
> 2 Who was consulted to reach the decision
> 3 What known factors may influence the decisions
> 4 What the decisions are, with a justification for each
> 5 When further *best interests* meetings should be held:
> - as a routine
> - to discuss a particular decision if it is needed.

7 Ethical considerations – the subjective challenges

What is it like to be in VS or MCS?

Consciousness is the central fact to human existence, but its existence in another can never be known – only inferred.

Families often ask what it is like to be in VS or MCS, and whether the patient is in pain. A number of authors have addressed this question.[91–93]

Patients in PVS are believed to lack *any* capacity to experience the environment, internal or external, but complete certainty that primal sensations, such as pain, are absent is impossible to know.[93] Patients in MCS, on the other hand, are likely to experience pain but may not exhibit the behaviours that are usually seen in people with pain.

Pain is common in patients with other severe neurological disabilities and may be a problem in patients with MCS. Sources include:
- damage to the central pain processing pathways, which may also cause hypersensitivity, allodynia etc
- muscle spasticity (typically experienced as cramps)
- joint malalignment and heterotopic calcification
- pressure areas, with or without actual pressure sores/wounds
- visceral pain from bladder, bowels etc.

Careful observation of pain-related behaviours (grimacing, moaning, groaning etc) provides the mainstay of monitoring and should be taken to indicate discomfort and not some reflex or spontaneous movement or behaviour.

The evidence on pain

Researchers have investigated pain experience through the use of PET scans and functional connectivity analysis in patients with PDOC compared with normal controls.[69,91] Preliminary findings in a very small sample suggest the following:

- In VS patients, although painful stimuli reach the primary somatosensory cortex (the area of the brain that 'senses' pain and coordinates reflex responses) they do not reach the higher-order associative cortices (those areas that are responsible for perception and awareness of pain).
- By contrast, MCS patients showed a close to normal pattern of neural activation,[69] suggesting that the ability to experience pain, and presumably other symptoms, is probably unimpaired.
- Neuroimaging studies also suggest the possibility of emotional response and processing, as well as pain in a minority of patients with MCS.[94] Therefore the potential for continuing mental distress is of equal concern.

Whilst not provable, this offers plausible, empirical reasons to suggest that living in a minimally conscious state with some level of awareness could, in some circumstances, be a worse experience than living in a vegetative state with no awareness.

Clinicians are therefore urged to pay careful attention to the prevention, management and monitoring of pain and discomfort for patients with PDOC. For example, the identification of a painful condition (such as a dental abscess or ingrowing toenail) should lead not only to the prescription of analgesia, but to treatment for the underlying problem. However, pain symptoms that accompany neurological disability (as described above) will not always be avoidable.[93]

These factors should also be borne in mind when weighing up the balance of benefits and harms to inform *best interests* decisions relating to treatments that are given to prolong life.

Decisions about life-sustaining treatments in PDOC

An exposition of the ethical and philosophical principles underpinning the value of consciousness is beyond the scope of these clinical guidelines, but is explored in the RCP guide to oral feeding.[87] Instead we will focus on the practical challenges faced by clinicians, families and the legal teams who seek to support *best interests* decisions regarding life-sustaining treatment.

Life-sustaining measures for catastrophically brain-injured patients are initiated in the hope that they will recover consciousness, but there are reasons to be concerned about people who achieve only very limited recovery. The legal basis for a finding that provision of life-sustaining treatment should not be continued is based on the treatment being futile where the patient is in a permanent VS (see sub-section 8, this section).

Whilst life-sustaining treatment may encompass a number of interventions (including resuscitation in the event of cardiorespiratory arrest, and the use of antibiotics in the case of a life-threatening infection) the most emotive is artificial nutrition and hydration (ANH). This is partly because nutrition

and fluid are considered by some to be staple requirements rather than a medical treatment, and partly because death will inevitably follow within a few days or weeks of withdrawal. Recent General Medical Council (GMC) guidance[95] has introduced a change in terminology, from ANH to CANH (clinically assisted nutrition and hydration) to emphasise the clinical nature of the intervention. CANH encompasses hydration and feeding both via the intravenous route and through nasogastric and gastrostomy tubes.

There remains ethical debate about withholding and withdrawing CANH for people with PDOC.

The debate is rooted in three issues:
- What is causing the patient's death – the event that caused the brain damage or the removal of treatment?
- The value of life for patients who are conscious, but unable to experience beyond a basic level, and are not terminally ill in the conventional sense.[96]
- Whether death by dehydration may cause suffering – especially in patients with MCS.

From a legal and ethical perspective, the catastrophe that led to the brain injury is the ultimate cause of the PDOC and subsequent death.
- Any medical intervention that continues to be needed only because of that event would never have been required, but for the brain injury.
 - Life-sustaining treatments postpone a death that otherwise would happened at, or soon after, the time of the brain injury. Treatments may have to be started early, when the outcome is uncertain, which in retrospect would not have been started if the eventual outcome had been known.
- The consequences of withdrawal of treatment, no matter how long after the event, should be regarded as due to the brain injury.
- Treatment withdrawals are justified by a wish to avoid harm once life-sustaining treatments are deemed no longer to be a benefit. They do not have the motive of bringing about death.

The difficulty is that the longer a treatment is in place, the more it feels 'normal'. Hence withdrawal of CANH may seem like a new or separate cause of a death, and clinicians may feel as though they are actively terminating life, rather than simply desisting from intervention to postpone death happening. However, staff should be reassured that they are not legally culpable as long as the proper legal decision-making process has been followed.

8 Applications to the Court of Protection

The vast majority of health and welfare decisions in respect of a patient with PDOC, for example about the treatment or otherwise of inter-current or other illnesses or about resuscitation, can be made by the treating team according to the principles in the MCA without any involvement of the Court of Protection.

However, where there is unresolved disagreement as to what is in a patient's best interests (whether within the clinical team or between relatives and the clinical team), the involvement of the Court may be necessary to resolve the matter.

Applications for withdrawal of CANH

The recent Supreme Court judgment in the case of Aintree vs James (2013) (www.supremecourt.gov.uk/decided-cases/docs/UKSC_2013_0134_Judgment.pdf) relates to an application to the Court to withdraw elements of life-sustaining treatment in the somewhat different context of a progressively deteriorating medical condition. Nevertheless, it upholds principles that are relevant to the context of PDOC as discussed in these guidelines.

- A patient cannot order a doctor to give a particular form of treatment (although he may refuse it) and the Court's position is no different (para 18).
- However, any treatment which doctors do decide to give must be lawful. Generally it is the patient's consent which makes invasive medical treatment lawful (para 19).
- If a patient is unable to consent, it is lawful to give treatment that is in his best interests (para 20).
- The fundamental question is whether it is in the patient's best interests, and therefore lawful, to give the treatment – not whether it is lawful to withhold it (para 21).

The judgment further emphasises that *best interests* should be considered in the widest sense, not just medical but social and psychological (para 39).

- Where a patient is suffering from an incurable illness, disease or disability, the prospects for success of a given treatment should be considered in respect of a return to a quality of life which *the patient* would regard as worthwhile (para 44).
- The purpose of the *best interests* test is to consider matters from the patient's point of view. That is not to say that his wishes must prevail, any more than those of a fully capable patient must prevail. We cannot always have what we want. But insofar as it is possible to ascertain the patient's wishes, feelings, beliefs and values, it is those that should be taken into account in making the choice for him as an individual human being (para 45).

In all cases where withdrawal of clinically assisted nutrition and hydration is proposed an application to the Court of Protection is mandatory.

Vegetative state

The legal precedent for withdrawal of CANH in VS was set in 1993 in the case of Anthony Bland, who sustained catastrophic anoxic brain injury in the 1989 Hillsborough disaster. The legal arguments for withdrawal in that case are summarised in Box 4.4.

Box 4.4. The legal arguments for withdrawal of clinically assisted nutrition and hydration (CANH) from patients in a permanent vegetative state.

- The legal duty of a doctor is normally to ensure that those in his/her care receive adequate care and nourishment. It will usually be appropriate to treat the patient while diagnosis and prognosis are established. Non-voluntary treatment is lawful because it is justified by necessity.
- However, once it is established that the patient is in VS with no prospect of recovery the position changes. Necessity can no longer be claimed because further treatment is futile.
- Although the fundamental principle of law is the sanctity of human life, this is not an absolute principle. Life does not have to be prolonged regardless of circumstances.

continued

> **Box 4.4.** *continued*
>
> - Decisions regarding medical treatment will usually involve balancing the benefits and dis-benefits of the treatment proposed in the light of a wide range of clinical and social factors.
> - However, assessing 'best interests' in relation to continuing with CANH in cases of permanent VS does not require such a balancing exercise. In the case of Anthony Bland, the House of Lords found that such an approach was inappropriate – where the patient in VS has no conscious life there is nothing to balance in favour of preserving life.

As a result of that judgement, the legal position is that it is lawful to withdraw CANH from a patient who is in VS. Since then, over 40 applications have been made to the Court of Protection to withdraw CANH in patients in permanent VS, and the required declarations have been granted.

Once it is known that a patient is in **permanent VS**, the Court accepts that further treatment is futile. It is not only appropriate but necessary to consider withdrawal of all life-sustaining treatments, including CANH. Indeed, to continue to deliver treatment that prolongs their life in that condition in the absence of a reasonable belief that treatment is in the patient's best interests may be regarded as an assault (Bland [1993] AC 789 per Lord Browne-Wilkinson at 883).

Minimally conscious state

There remains controversy about ending life-sustaining medical treatment for persons in MCS.

The basis for the determination in the Bland case, that a person in PVS has no legal 'interests' because of their lack of consciousness, has little relevance to those in MCS who have some, albeit limited, consciousness.

Consciousness does not of itself preclude the Court from endorsing the withdrawal of life-sustaining treatment for any patient who lacks capacity, including those in MCS. However, as our understanding of disorders of consciousness has grown, so has the ethical complexity of assessing the value of existence.

MCS covers a wide range of variation in responsiveness and awareness. For some patients it is a transitional state on the way towards fuller (or full) recovery of consciousness. Others, however, will remain permanently in a state of diminished consciousness, and it is this group for whom there is special ethical concern.

- Patients in MCS may have perceptible positive and pleasant experiences.
- As noted above, research evidence suggests that MCS patients have the ability to experience pain and distress.
- Remaining aware, yet losing many aspects of life that constituted one's 'personhood' with its projects, attachments and interests, could be worse than losing awareness completely.

Life-prolonging care may therefore have negative value for patients who experience some minimal awareness, but have little to no hope of further recovery and little prospect of escaping a condition that is unacceptably burdensome and inconsistent with the values and beliefs they held before injury. For these

reasons the *best interests* decision-making in respect of someone in MCS is particularly complex and often finely balanced.

The law at the time of this report offers little guidance as there has only been one court case concerning the withdrawal of CANH from a patient with a diagnosis of MCS (W v M [2012] 1 All ER 1313). The judgement in this case did confirm that the Court can make a declaration to withdraw CANH in a case of a patient in a MCS, but in this case the judge found the balance of benefits versus harms to favour the continuation of CANH.

The Court has also considered cases with disorders of consciousness not amounting to MCS. In addition, there are a number of reported cases where the Court has sanctioned the withdrawal of life-sustaining CANH from persons lacking capacity who have no disorder of consciousness. Therefore, the fact that there is as yet no precedent case in which the Court has approved the withdrawal of CANH in a case of MCS should not deter such applications. Indeed, where there is evidence that a patient in MCS would not wish to continue to receive life-sustaining treatment were they able to indicate their choice, the GDG recommends (and the patient's right to autonomy arguably requires) that such cases are brought to Court in order to establish the patient's best interests in this respect.

The same legal principle of acting in accordance with the patient's best interests will apply in a case of MCS – as in all decisions about medical treatment of patients lacking capacity. *Best interests* decisions with respect to life-sustaining treatment should be made on the balance between positive and negative experience, bearing in mind what is known about the previously expressed wishes and values of the individual.

In such decision-making, not only the medical issues but also the social and religious beliefs and values of the person (including their previously expressed wishes and feelings) must be weighed in the balance of risks and benefits when determining best interest in respect of continued treatment. Those beliefs and values about what kind of life counts as worthwhile should be respected for the same reasons that we respect the beliefs and values of other people.

9 Other factors affecting referral to the Court of Protection

Apart from the ethical dilemmas noted above, factors that often deter applications to the Court of Protection include the following:
- Lack of knowledge on the part of professionals and NHS trusts about their responsibilities in this respect and the relevant application procedures.
- Lack of information being provided to the family about available options, and an apparent reluctance from some clinicians to raise the issue or take ownership of the decision.
- The Court costs associated with making the application which usually run into thousands of pounds and are borne by the applicant. This should usually be the NHS trust responsible for commissioning or providing the patient's treatment. However, in instances where a family member makes the application, any funding from the Legal Aid Agency is means tested on the applicant as opposed to the patient, so the family member may have to bear their own (considerable) costs.
- The length of time (which may be months or years) that the legal process sometimes takes.
- Distress arising from media coverage and adverse publicity, as such applications will invariably be heard in public (albeit with anonymity orders in place).

- Families also report fearing being judged or unsupported by their relative's care team or burdened by a sense of responsibility for causing harm or 'signing a death warrant'.[86,97]

It is the strong view of the GDG that family members should not be in the position of having to make an application to the Court to withdraw CANH. The responsible NHS commissioning body has a duty of care to bring the application to the Court if the treating health team find (on the basis of *best interests* decision-making) that continuation of CANH is not in the patient's best interests. In the case of disputed *best interests*, the responsible trust should apply to the Court for clarification and fund that application.

Public funding should be made available to support applications, either from the Legal Aid Agency or from healthcare budgets. Every effort should be made to ensure that applications are processed in a timely and efficient manner.

Individual planning

Individuals can also assist by giving consideration to their wishes in this respect as they draw up advance care planning documents such as a Welfare LPA or Advance Decision to Refuse Treatment (ADRT) as part of their future personal planning while they have capacity.

Whilst it is recognised that patients might change their mind, especially after a disabling event, the existence of a valid and applicable ADRT provides the best indication of the patient's wishes.

In the case of treatment refusal, an ADRT is binding on the treating team and hence likely to be upheld by the Court.

When drawing up an LPA, the appointment of a named Welfare LPA for healthcare decisions may also assist in providing a greater level of input for family members into treatment decisions, or ensure that a chosen trusted person is the decision-maker.

The GDG acknowledges that most of us do not draw up such documents and it is likely that this will remain a minority choice. Ideally this should change, and to this effect a suggested template for an ADRT is offered in annex 4c (rcplondon.ac.uk/pdoc), in order that the instrument may assist the Court of Protection to uphold a person's wishes in the event of *best interests* applications.

The suggested template provided in electronic annex 4c at rcplondon.ac.uk/pdoc is for an ADRT with respect to life-sustaining treatment in the event of loss of mental capacity due to PDOC and other long-term neurological conditions.

Clinicians and conscientious objection

'Conscientious objection' to an act is the claim that it would violate the individual's conscience, resulting in a loss of integrity or shame. A conscience may not, of course, be well informed, but the claim to conscience implies a certain seriousness of conviction or belief.[87]

The right to freedom of conscience in Article 9 of the European Convention on Human Rights was given effect by the Human Rights Act 1998.

Clinicians remain divided on whether they feel able to support withdrawal of life-sustaining treatment for patients in PDOC:

- Some readily accept that if the patient's balance of negative experiences outweighs the positive, to prolong their life artificially only extends their period of suffering; CANH should be withdrawn on the basis of the 'First do no harm' principle.
- Others believe that withdrawing CANH from a patient who has some level of awareness, in the knowledge they will certainly die of dehydration within 2–3 weeks, is against the basic creed of care.

Any practitioner is entitled to hold a moral viewpoint, but they are not entitled to impose that view on others, unless the law mandates.

Clinicians should be aware that any strongly held personal views and beliefs are a source of conflict of interest, which must be declared. This does not necessarily preclude them from remaining the decision-maker. However, if the individual clinician could not sanction a *best interests* decision in one direction, they should hand over the care of the patient to a clinician who can.

Participation in withholding or withdrawal of CANH could lead to conscientious dissent.

- Where such dissent cannot be overcome by discussion within the multidisciplinary team, the practitioner should withdraw from the patient's care, having first ensured that continuity of care is maintained with the involvement of another practitioner.
- A similar situation could arise where a practitioner might have an objection to providing or not withdrawing other forms of treatment.
- Whenever possible, patients or families should be notified of the professional's views at the time of admission or before a crisis occurs. Such disclosures are especially important in nursing homes and longer-stay institutions.
- Allowing patients or their surrogates time to choose another doctor or facility that will honour an Advance Decision to Refuse Treatment is far preferable to waiting until the patient's condition deteriorates before attempting a transfer.[98]

Similar considerations apply to institutions and care homes, some of which have a strong underpinning religious creed or tradition. Provider organisations that carry religious or other convictions which would prevent them from convening a *best interests* meeting that could endorse a decision to withdraw life-sustaining treatment, should declare that as a conflict and make arrangements for the *best interests* meeting to be carried out independently.

Summary

This section above all others in this document highlights some philosophical and moral issues that raise more questions than definitive answers. We have sought to identify some of the complexities and dilemmas that clinicians face in the day-to-day management of patients with PDOC, and to describe some of the legal and ethical framework that underpins current approaches to decision-making, particularly with respect to withdrawing life-sustaining treatments.

The next section provides some practical advice to support clinicians in their approach to planning and the provision of end-of-life care.

Section 4 Ethical and medico-legal issues: Summary of recommendations

	Recommendation	Grade
4.1	**Documentation of lack of capacity** Assessment of mental capacity must be specific to the decision in hand at the time that it is made. By definition, however, patients in PDOC lack the mental capacity to make decisions regarding their care or treatment. 1 The lack of mental capacity should be formally documented in the patient records in accordance with the two-stage test of capacity along the following lines: *'X lacks the mental capacity to make decisions regarding his/her care and treatment due to severe brain injury, and because he/she lacks the ability to understand and retain information, to weigh it up in order to reach a decision, or to communicate a decision.'*	E1/2
4.2	**Decisions regarding treatment and care** 1 Because patients in PDOC lack capacity to make decisions regarding their treatment and care, all decisions in these respects should be undertaken on the basis of *best interests*, under the terms of the Mental Capacity Act 2005 (MCA).	E1/2
4.3	**Advance Decisions to Refuse Treatment (ADRT) and Welfare Deputy** 1 When a patient is in a coma or PDOC, the healthcare team should establish **as soon as possible** whether: a the patient has made a valid and applicable ADRT covering the clinical situation that has arisen; if so, it must be followed (MCA s26) b the patient has a Health and Welfare Lasting Power of Attorney ('Welfare LPA') or a Court-appointed Welfare Deputy whose powers extend to cover the particular treatment decision in question; if so their decision must be followed (MCA s19(6) and s9(1)(a)) c if the Welfare LPA's or Deputy's powers do not extend to this particular decision they must nevertheless be consulted about healthcare decision-making and their views taken into account (MCA s4(7)). 2 The treating team should ask to see documentation for any ADRT, LPA or Deputy in order to understand the extent of their authority and the treatment decisions that they cover.	E1/2
4.4	**Identifying key family members** 1 The clinical team should identify which people have a close emotional attachment to the patient and who have a legitimate interest sufficient to allow disclosure of clinical information about the patient as a part of providing support. *These people will be referred to as 'family' from here on, recognising that not all people will actually be family members.*	E1/2
4.5	**Independent Mental Capacity Advocate (IMCA)** 1 When a patient does not have any close family or friends to represent and advocate their views (or the family are deemed 'inappropriate to consult'), then an Independent Mental Capacity Advocate (IMCA) should be appointed and consulted in respect of *best interests* involved. 2 Where family and/or friends are considered not 'appropriate to consult with', an IMCA is appointed instead. The responsible body (NHS or local authority) should give the reasons for this and the rationale for involving an IMCA should also be provided to the family.	E1/2
4.6	***Best interests* decision-making** 1 In the absence of a valid and applicable ADRT, or appointed Welfare LPA/Deputy, decisions regarding care and treatment should be made by the treating team on the basis of *best interests*, taking into account what is known about the patient's likely wishes.	E1/2

2 Families should be consulted as part of the decision-making process, but it should be made clear that they are being asked what the patient would have wanted under those circumstance, not for their own views.

3 If a family member has been officially appointed as the patient's Welfare LPA/Deputy with powers to address the treatment in question, it is essential that they are involved in any *best interests* meeting to make decisions regarding treatment and care.

4 The *best interests* checklist should be used to document the decisions required and ensure that the appropriate people are involved in the decision-making process.

4.7 Obtaining information about the patient's likely wishes: E1/2

1 Within 2 weeks of onset of coma/PDOC, the healthcare team should discuss with family members and/or close friends:

 a what beliefs and values the patient had that would be likely to influence their decision-making were they still to have capacity

 b any other factors the patient is likely to have considered when making a healthcare decision, and these should be documented.

2 The healthcare team should stress to family members that the main question is: 'What would the patient have decided and why, were s/he able to make the decision?'

4.8 Formal *best interests* meeting E1/2

1 Within 4 weeks of onset of coma/PDOC, the healthcare team should convene a formal *best interests* meeting with the family/close friends, and the Welfare Deputy or LPA or IMCA if one is in place, to discuss and document the factors relevant to *best interests*.

2 The meeting should consider decisions concerning any emergencies likely to arise in the near future.

3 Further *best interests* meetings should be held:

 a at a planned reasonable interval, eg 2–3 months from the initial meeting

 b when circumstances already agreed in advance arise

 c whenever an unforeseen or important new decision needs to be made.

Section 5
End-of-life issues

1 End-of-life planning

End-of-life planning is normally considered as part of advance care planning – a discussion between an individual, their care providers, and often those close to them, about future care undertaken before the person loses capacity.[99]

For patients with PDOC it is good practice for the treating team to consider ahead of time the most significant or likely clinical events which may occur, and how best to manage them, even though the patient cannot take part in the discussion. This holds some particular challenges, as noted in Section 4.

By definition, patients with PDOC lack the capacity to make decisions about their care, and decisions must be made on the basis of their best interests in accordance with the provisions of the Mental Capacity Act 2005.* For the majority, injury comes suddenly and unexpectedly, so few will have made a valid and applicable advance statement about their wishes in this context, although some may have drawn up the documents to create a Welfare LPA. In some cases, the court may have appointed a Welfare Deputy.

In the absence of a legally appointed proxy, decisions about care planning and end-of-life management are ultimately made by the responsible senior clinician on the basis of the patient's best interests – unless they concern planned withdrawal of clinically assisted nutrition and hydration (CANH), in which case they require a decision by a judge of the Court of Protection.

The family role in planning end-of-life care

Families play a critical role in providing information about the patient's likely wishes in any given situation, and their input is integral to the process of identifying the patient's best interests.

Decisions regarding end-of-life planning may be particularly emotive, however.
- Some individuals, and families, have strong values that make them believe in the continuation of life-sustaining treatment whatever happens.

*For those aged over 16, or in accordance with common law for those under 16.

- Some may cling to the hope of future recovery, and find discussion about end-of-life planning negative – a sign that the clinical team is 'giving up' on the patient.
- For others (as noted in Section 3), the state of existence of their loved one may be in clear contradiction to that person's prior expressed views on how they would want to live.

Nevertheless, some families may feel guilty expressing a belief about what would be best for the patient[100] or may be torn between a knowledge of the patient's prior expressed wishes *against* prolongation of treatment and their own wishes for its continuation.[97]

Those who feel strongly that a patient's prior expressed wishes to reject treatment should be respected may feel angry and frustrated by the formal processes to be followed before withdrawal of life-sustaining treatments, and the length of time it can take to make such decisions.

All families, regardless of their views on what the patient would want, may also feel distressed about the available options for end-of-life planning.[86] In all these scenarios, families require information and support.

Moreover, family attitudes may change over time. Having often been told in the early stages that the patient is likely to die, families may interpret their survival against the odds as evidence of the patient's will to live and a sign of future recovery.[86,97]

However, with hindsight, efforts to save their loved one's life may be viewed with regret. One family member said: 'Would that they hadn't got to Charlie in time to resuscitate him – knowing now what I didn't know then'.[86]

Even those who fight for all active measures in the early months or years may change their minds about the appropriate course of action in the future.[86]

This underlines the importance of continued communication, with the provision of information and support for, and a willingness to listen to, families throughout the patient's journey.

2 Decisions about life-sustaining treatment and ceiling of care

As part of clinical treatment planning for patients with serious illness or injury it is appropriate to consider decisions about ceiling of care, and in particular to plan for decisions that may require rapid 'out-of-hours' intervention by emergency teams who are unfamiliar with the patient.

Key decisions may include whether or not to:
- use prophylactic treatments such as antithrombotic agents, cardio-protective agents, seizure prophylaxis
- use antibiotics in the instance of life-threatening infection
- use cardiopulmonary resuscitation in the event of cardiac arrest
- withdraw clinically assisted nutrition and hydration (CANH).

Such decisions will need to take account of:
- the likelihood that treatment will be effective or futile
- the benefits, burdens and risks of treatment – the best and worst outcomes
- the patient's likely wishes, based on what is known of their values and beliefs.

The timing of these decisions varies, some being required at an earlier stage in the care pathway than others.

Although cardiac arrest is one of the least likely causes of sudden deterioration in this group of patients, cardiopulmonary resuscitation (CPR) is often singled out for consideration because:
- it has maximal impact (ie saving the patient from sudden death) and requires immediate action
- it has ongoing care implications and can also harm a patient
- the decision of whether or not to offer CPR is relevant from a relatively early stage in the care pathway.

Initiating discussion with the family regarding 'Do not attempt CPR' decisions may be particularly difficult for the reasons discussed below. The GDG believes that discussion should be normalised as far as possible:
- Care planning and treatment decisions should be considered by the clinical team together with the family from an early stage in the pathway, starting with the most likely scenarios (eg seizures, infections etc) and those for which interventions *are* likely to be offered.
- In the context of this general conversation, cardiac arrest can then be seen as far less probable and decisions not to offer CPR are less likely to be interpreted as a blanket withdrawal of care.
- Whatever decision is made should be clearly recorded in writing in an unambiguous manner.

'Do Not Attempt Cardiopulmonary Resuscitation' (DNACPR) decisions

Decisions not to attempt CPR were previously referred to as DNAR ('*Do not attempt resuscitation*') decisions.[101] However, this term was sometimes interpreted as a decision that no active treatment should be provided.

The recent General Medical Council (GMC) guidance for treatment and care towards the end of life[95] uses the term 'Do not attempt cardiopulmonary resuscitation' (DNACPR) to clarify that the decision refers only to the use of CPR in the event of a cardiac arrest:
- The guidance also noted the general low success rate and the burdens and risks of CPR, including harmful side effects (eg rib fracture, damage to internal organs); adverse clinical outcomes such as hypoxic brain damage; and the fact that, if unsuccessful, the patient dies in an undignified and traumatic manner.
 - CPR procedures carry a high risk of anoxic brain damage even in the normal population.[102] At best only 15–20% of patients survive to discharge following an 'in-hospital cardiac arrest'[103] and only 3–7% return to their previous level of functional capacity.[102]
 - Quality of life among survivors is better for those who required only short resuscitation procedures (<2 minutes).[104]
- It further noted that, in cases in which CPR might be successful, it might still not be seen as clinically appropriate because of the likely clinical outcomes. When considering whether to attempt CPR, the

clinical team should consider the likelihood of success, the benefits, burdens and risks of treatment that the patient may need if CPR is successful.

For patients who lack capacity to make advance treatment decisions

DNACPR decisions are made on the basis of *best interests*, weighing up the above and taking into account the patient's wishes insofar as these can be known.
- Where there is no Welfare LPA in place:
 - the responsibility for determining whether or not resuscitation is in the patient's best interests lies with the lead clinician with clinical responsibility for the patient at the time.
 - family/carers/next of kin do not have decision-making responsibilities or rights in this circumstance. They should never be placed in a position such that they feel they are making a DNACPR decision.
 - discussion with the family should be focused on trying to ascertain the patient's views prior to incapacity, as part of determining their best interests.
- Where there is a Welfare LPA in place *and* the terms of their appointment expressly cover decisions about life-sustaining treatment, then the Welfare LPA can:
 - make a legally binding decision to refuse CPR for the patient
 - by their agreement, give the lead clinician the legal authority to provide CPR if offered.

However, where the treating clinician has determined that CPR would be futile, or on balance be more likely to be harmful than beneficial, they are under no obligation to offer it, and the Welfare LPA cannot demand CPR if it is not being offered.

If agreement cannot be reached after sensitive discussion, a second opinion should be accessed.

DNACPR decisions for patients with PDOC

For patients with very severe brain injury, CPR for cardiac arrest is unlikely to be successful and is rarely appropriate, as even short periods of hypoxia are likely to lead to further brain damage and a worse clinical outcome. As such, it represents 'futile' treatment for which the harms outweigh the benefits in the majority of cases. It is therefore clinically unjustified and inappropriate in the majority of cases.

For the majority of patients in PDOC, it is therefore normally appropriate to apply a DNACPR decision. The overall clinical responsibility for decisions about CPR rests with the most senior clinician in charge of the patient's care.[101] Wherever possible, however, a DNACPR decision should be agreed with the whole treating team.

The process of weighing up a DNACPR decision requires careful consideration, and so by definition must be made ahead of the time when CPR might actually be required. When the decision has been made, therefore, the responsible clinician signs a 'DNACPR form' to communicate the decision to others involved in the patient's care. This, in effect, instructs the staff caring for the patient at the time not to initiate CPR or to call out the cardiac arrest team. As this is a decision relating to future treatment, the consultant/team is responsible for reviewing the instruction at appropriate regular intervals to confirm that the decision is still in the patient's best interests. All such forms should therefore have an explicit review date.

In certain circumstances, however, there may be some valid clinical reasons *not* to apply a standard DNACPR form:

1 At a very early stage post injury (eg up to 6–8 weeks) and depending on the nature and extent of the brain injury, there may be genuine uncertainty about the prognosis for recovery.

2 In some settings, calling the cardiac arrest team may be the only way of getting rapid medical attention – for example in the event of simple reversible problem, such as a blocked tracheostomy, which could lead to cardiorespiratory arrest if not dealt with rapidly.

'Short resuscitation only' decisions

Where there is genuine uncertainty about the prognosis, decisions to provide for 'short resuscitation only' (eg 5–6 minutes of CPR, but stopping short of a prolonged attempt, continued ventilatory support or transfer to intensive care) may offer an appropriate option to:

- enable nursing staff to call for rapid medical assistance in the event of a reversible condition (such as a blocked tracheostomy tube or a transient arrhythmia)
- reinforce the message to medical cover teams that active management of other intercurrent medical/surgical conditions is still appropriate.

Decisions that short resuscitation should be provided should be recorded and be accompanied by a clear direction with respect to the ceiling of care, in order to guide on-call teams who are not familiar with the patient. For example, that 'prolonged resuscitation, ventilation or intensive care treatment are inappropriate; but all other active medical treatment (such as antibiotics for infection) should be given as required'.

Such instructions should not be confused with 'go slow' or half-hearted attempts at CPR, which will never be appropriate and must not be endorsed. They are specific instructions to assist the emergency medical team in providing effective and appropriate care for defined conditions, whilst applying a ceiling of care to avoid futile treatment that is clinically unjustified.

Explaining to the family

Best practice recommends that DNACPR forms should only be issued after discussion with patients or their family.[95] Indeed it is a legal requirement under MCA, where practicable, to consult with those close to the patient as part of *best interests* decision-making. However, this depends on whether the discussion is in order to arrive at a decision, or to explain a decision that has already been reached on the basis that treatment would be futile.

Family members of patients in PDOC are often distressed by such discussions for several reasons:

- They may not yet have come to terms with the patient's poor prognosis for recovery.
- They may interpret a DNACPR decision as an instruction for 'no active treatment' and feel that the medical team is 'giving up on' their loved one.
- They may believe that they are being asked to make a decision to *withdraw* treatment. Despite careful explanation about the scope of DNACPR decisions and that the clinical team is responsible for them, some families still believe that they personally are being asked to make the decision, and they do not want the burden of responsibility or to feel implicated in a loved one's death.

Inability to discuss DNACPR decisions with the family should not preclude the decision. If the decision has already been made on clinical grounds that CPR would be a futile treatment, the clinician is under no obligation to offer it.

It is generally good practice to explain this to the family unless, in the clinician's view, this would cause significant undue distress. In this case, they may decide to defer discussion until a later date. However, discussion should be the norm and so there should be a high threshold for withholding information regarding the existence of a DNACPR decision from a family. If a DNACPR form is issued without discussion with the family, the reasons for this should be documented and it is wise to seek a second opinion from a consultant colleague.

The practice of routine decision-making with respect to the ceiling of care is now standard in most acute trusts. Whether the decision relates to DNACPR or short resuscitation only, it is appropriate to normalise the conversation between medical staff and the family on this subject. Box 5.1 summarises advice about communicating DNACPR decisions.

Ongoing DNACPR decisions

In the context of PDOC, as the factors that have led to a conclusion that CPR would not be in the patient's best interests are unlikely to change over time, then once a DNACPR decision has been made it is very unlikely to be revoked unless the patient emerges into consciousness. Repeated discussion with the family each time the patient moves to a different care setting may cause unnecessary distress. Therefore, DNACPR decisions should remain valid and applicable across all settings including acute care, nursing home and ambulance transport until an agreed review date or a change in condition. A unified form is currently undergoing validation to address this problem.

Where a carefully drawn up treatment decision exists it is unwise for it to be revoked as a matter of course on change of care setting. A blanket policy to revoke such decisions in respect of new admissions may well not be in the patient's best interests and hence could well be unlawful. Receiving hospitals and care homes should therefore never simply rescind a pre-existing DNACPR decision without a further and properly documented *best interests* determination having been made. It is, however, incumbent on the discharging team and the receiving team to review any DNACPR forms on transfer to ensure that they are still applicable.

A link between the proposed national clinical database for patients with PDOC and electronic records relating to palliative and end-of-life care would be extremely helpful in this respect, for ensuring that any *best interests* decisions regarding ceiling of care are transmitted on to those healthcare systems that need to know this information within a very short space of time (eg 10–15 minutes) in order to act appropriately.

Box 5.1. Communicating decisions regarding DNACPR.

The discussion between medical staff and family should include a clear explanation of the following:

- That future care planning is a routine part of clinical decision-making that is considered for all patients who are unable to express their own wishes.
- This includes plans for the most likely scenarios, eg infection, seizures and sudden cardiac arrest.

Good practice starts with discussion about the most common scenarios and actions (eg antibiotics for infection, prophylaxis for seizures etc) and progresses to the less likely events with the poorest outcome (eg CPR and decisions whether to attempt it or not).

The clinician should explain:

a why CPR is unlikely to benefit the patient
b what the likely outcome would be
c that the decision whether or not to offer CPR lies with the treating team and not with the family and is to be determined solely on the basis of the patient's best interests
d that except where there is a Health and Welfare LPA with authority to make decisions regarding a refusal or acceptance of CPR if offered, the family's only role in this respect is to indicate what they believe the patient would have wanted in this context.

3 Withdrawing other life-sustaining treatments

With the exception of withdrawal of CANH (see below), the decision to administer or withhold life-sustaining treatments is one that must be taken by the treating team on the basis of identified best interests, unless the patient has made an ADRT or given explicit authority in this area to a Welfare LPA.

Doctors should weigh up the likely benefits and harms of each potential treatment, in conjunction with family members, to determine the patient's likely views and wishes.

In general, treatments that are given to control symptoms or improve ease of care will be in the patient's best interests.

Once it is deemed that recovery to a condition that offers what the patient would have considered reasonable quality of life is unlikely, then it is usually appropriate to consider whether or not to withdraw/withhold life-prolonging treatments such as:

- prophylactic agents, eg thrombo-prophylaxis, statins etc
- antibiotics for life-threatening infections.

Such decisions should be made on the basis of *best interests* and documented in the records.

In certain cases it may be appropriate to consider withdrawing/withholding such treatments *prior* to establishing the likely prognosis. For example, if the patient had expressed a strong wish not to be treated if there was a risk of a poor outcome, but had not made a valid ADRT. This should be considered in earlier *best interests* discussions and, if there is a significant and insoluble difference of opinion, brought urgently before the court.

Permanent vegetative state

Section 1 describes the circumstances under which a patient may be diagnosed as being in a 'permanent VS', from which future recovery of consciousness is highly improbable.

Once it is known that a patient is in a permanent VS, further treatment is considered futile. Processes to consider withdrawal of life-sustaining treatments, including CANH, should begin on the basis of their best interests, and in discussion with the family. The arguments and legal details are in Section 4.

The decision to withdraw CANH cannot be made by clinicians alone (see Section 4). An application must be made to the Court of Protection in all cases, where a judge will decide if withdrawal of CANH would be lawful.

Even where the patient has made a valid and applicable ADRT, the relevant Practice Direction of the Court of Protection requires that an application must be made to the Court. Where there is a valid ADRT, the decision may be a simple and rapid one, but the Court will always wish to scrutinise its validity and the accuracy of the diagnosis of permanent VS.

Operational procedures for applications to withdraw CANH from patients in permanent VS are listed in Box 5.2

On occasions, the initiation (and cost) of bringing applications to the Court has been left to the family. The GDG believes this is wrong. The legal costs of the Court application should be borne by the responsible public body, and the onus for initiating the application should lie with the treating clinical organisation or those who commission the care.

Permanent minimally conscious state

A proportion of patients will be left minimally conscious until they die. The diagnosis of 'permanent MCS' is less well defined, and is described in Section 1. Depending on individual circumstances, a diagnosis of permanent MCS may be considered between 3 and 5 years following injury, and again denotes a state where emergence to consciousness may be considered highly improbable.

For patients who remain in MCS beyond these time points, it is also legitimate to consider whether withdrawing all life-sustaining treatments would be in their best interests.
- The presence of some degree of awareness does not prevent applications to the Court for withdrawal of CANH, once it is determined that a patient is in permanent MCS.
- Clinicians should consider this option as part of *best interests* decision-making, especially where there is valid evidence that the patient would not want to continue living in their current condition.

Box 5.2. Operational procedure for applications to withdraw CANH in a patient with permanent VS.

1 Diagnosis of a permanent vegetative state should only be made in accordance with the guidance laid out in Section 2 of this document.

2 Within 4 weeks of **the diagnosis of a permanent VS**, a formal *best interests* meeting should be convened between the treating team, the family, and the responsible health authority to decide whether continued life-sustaining treatment remains in the patient's best interests.

3 If it is decided that continuing life-sustaining treatment is in the patient's best interests, a formal further review of this decision should be arranged within 6 months.

In cases where it has been decided that it is not in the patient's best interests to continue active life-sustaining treatment the following recommendations apply.

4 The specialist rehabilitation team should inform the funding commissioning organisation in order to identify who will instruct lawyers to approach the Court of Protection with an application to withdraw CANH in accordance with the practice directions of the Court, within 4 weeks. Funding that application should be the responsibility of the NHS, and provided by the service commissioners.

5 The specialist neurological rehabilitation team should write a formal medico-legal report for the legal team to use to support its application. This should include:

 a a summary of the relevant formal assessments that have been made to reach a diagnosis of permanent VS and prognostication

 b a record of the formal *best interests* meeting, in which the decision was made to support the application

 c a preliminary balance sheet of benefits and harms.

6 The family (as defined in Section 1) should be offered support – practical, emotional and psychological. They should be kept informed about the clinical situation and legal process at all times, to the extent that they want. Anticipatory bereavement work may be required. Referral to the local specialist palliative care team may be appropriate and should be considered by the treating team.

7 The treating medical and nursing team should continue any CANH in place while the legal process is underway.

8 The treating clinical team and family should be given information about the process and its progress. They should be made aware that the Court hearing will probably be in open court, and that the judgement will be published (including on the internet), but that anonymity orders are likely to be put in place. They should be offered emotional and psychological support by the senior medical staff as needed.

9 The process of withdrawing CANH should be considered (see below) and plans made while the legal process continues; detailed recommendations about withdrawal are given later in this section.

Table 5.1. Example balance sheet for benefits and likely burdens of continuing CANH in a patient in MCS.

Benefits of continuing CANH	Likely burdens of continuing CANH
Direct effects of the intervention: preservation of life Avoids the discomfort associated with withdrawal of CANH and death through dehydration and nutritional deprivation. **The consequence of treatment withdrawal would be death by dehydration and nutritional deprivation with the patient possibly experiencing (i) thirst, (ii) hunger, (iii) discomfort, (v) distress, and (vi) pain for a 2–3 week period.**	**Direct effects of the intervention: ongoing discomfort/pain** Continuation of future episodes of physical discomfort associated with the periodic replacement of the PEG tube. Risks of vomiting, aspiration, abdominal discomfort on feeding.
Potentially positive aspects of continuing life Evidence from neurorehabilitation experts' statements as to any positive experiences and family/care staff's reports of behaviour, eg: 1 Any positive response to interactions with others • eg on visits from family, being read to, hearing familiar voices, or being given massages and physical comfort 2 Any positive response to external stimuli • eg on being taken on trips outside of care home, exposure to music, experiencing warmth of sun on face 3 Extent of any ability to communicate • eg patient can communicate (albeit inconsistently) in a way that leads to action by others to enact their wishes.	**Potentially negative aspects of continuing life** Evidence from neurorehabilitation experts' statements as to any negative experiences and family/care staff's reports of behaviours, eg: 1 Any apparent physical discomfort or pain at times 2 Any apparent emotional distress at times 3 Lack of dignity.
Opportunity for further stimulation and improvement in quality of life Neurorehabilitation experts' evidence as to whether further steps can be taken to (a) increase the likely positive experiences, and (b) reduce the likely negative experiences.	**Negative effects of continued stimulation/hyperstimulation** Neurorehabilitation experts' evidence as to likely negative experiences and effects of continued stimulation: hypersensitivity etc.
Patient has not expressed wish to have life ended if in MCS Eg where they have expressed firm religious and/or moral views with respect to the preservation of life.	**Extent to which continued life-preserving treatment is not compatible with the patient's previously expressed wishes** Eg where they have previously expressed a wish not to live in a dependent state, or where they have observed other family members in dependent states in later life and expressed the view that they would rather die sooner than continue in such a state.

When a patient is diagnosed as being in permanent MCS, there should be a formal *best interests* decision-making meeting between the treating team, the family, and the responsible commissioning health body to decide whether it is appropriate to make an application to the Court for withdrawal of CANH, based on the balance of *best interests*, considering the benefits and burdens of continued treatment.

Table 5.1 shows an exemplar balance sheet for considering withdrawal of CANH in a patient in MCS.

The operational procedures for supporting applications for withdrawal of CANH in patients in permanent VS are shown in Box 5.2. Items 5–9 can also apply in the context of permanent MCS.

4 Practical management of end-of-life care for patients with PDOC

Challenges for end-of-life care and place of death

Patients dying in VS/MCS pose a number of challenges for management which include the following:
- The process of dying is often prolonged and timing of death difficult to anticipate – there is often uncertainty over when to apply the end-of-life care pathways,[105] even after elective withdrawal of CANH (see below).
- Patients with profound brain injury typically have complex spasticity and involuntary movements requiring skilled postural handling techniques and specialist equipment often not available in standard hospice settings.
- Patients dying in VS frequently exhibit signs of 'physiological distress' (see below), which may give the appearance of suffering even when the patient him/herself is unaware. Such signs are distressing for family and care staff to witness.
- Patients dying in MCS may experience distress but not have the means to communicate their symptoms.
- Managing end-of-life care in this difficult situation often challenges care staff to their limits.

For all these reasons, end-of-life care for patients with VS or MCS requires a team-based approach with close coordination between specialists in palliative care and neurodisability management. The combined skills of both specialties are required to optimise medication, to support distressed family members, and also to support the care team.

It is rarely possible to provide the level of support required to allow patients to die within their own home. For patients who have little or no awareness of their environment, the importance of dying in their own home is usually less critical than the more immediate concerns described above.

Patients dying in PDOC should therefore usually be managed in centres with experience in the management of neuropalliative rehabilitation[106] or in specialist nursing homes, supported by a staff with the appropriate skills and knowledge of DOC. These sites must have access to specialist palliative care services.

End-of-life care following withdrawal of CANH

The withdrawal of CANH poses some particular challenges. Even though the cause of death is the original brain injury (see Section 4), families and staff on the ground understandably perceive

withdrawal of CANH as the cause of death because it is the most proximate event. This can be distressing for all concerned.

The aim of palliative care is to achieve the best quality of life while possible and then to provide a calm, peaceful and dignified death. Unfortunately, this is sometimes challenging to deliver for a number of reasons:

1 The principal process in the death is multi-organ failure from dehydration. Because patients with PDOC are often young and relatively fit, in contrast to many other terminal conditions this may take up to several weeks.

 a Enduring such a prolonged dying process can be very difficult, not only for the family but also for the attending care staff.

 b Non-specialist staff often need reassurance, because many are used to seeing the patient die within days of them stopping eating, drinking or CANH.

2 Although some patients may die peacefully, others may show a strong physiological reaction to the altered homeostatic balance resulting from deprivation of fluid and nutrients. The reflex physiological signs and hyperactivity in the brainstem can be extreme and unstable. Palliation must therefore be proactive closely monitored and capable of rapid responses.

There may be:

 a Sweating, tachycardia, agitation etc. In the absence of the normal homeostatic mechanisms these can be very dramatic.

 b Spontaneous and reflex movements such as roving eye movements, groaning, crying, teeth-grinding, chewing etc which may become more pronounced.

To the onlooker this gives the impression that the patient is aware and experiencing distress.

The burden of witness in this situation will be profound and should never be underestimated. Families/care staff require considerable support and explanation including aftercare for bereavement support.

Some reflexive behaviours (eg spasms in response to care interventions or oral hypersensitivity) that have been managed by PEG medications such as baclofen or clonazepam may increase when these are withdrawn. Continuation via PEG may involve significant quantities of fluids and so unnecessarily prolong the dying process. Medications that are still required to control unwanted symptoms/signs should therefore be replaced from the outset in the subcutaneous or intravenous drug regimen.

Use of sedation and analgesia

Even if the patient is not capable of experiencing emotions, sensations, cognitions or any symptoms, it is appropriate to provide some level of sedation and analgesia, if only to provide absolute assurance for family members and staff that the patient is not suffering.

Again there are two areas of difficulty:

1 Clinicians are naturally cautious and anxious to avoid the risk of being accused of deliberate overdose. Consequently, and despite strong evidence that opioids and strong sedative drugs may be given safely in these types of patient,[107] it is quite common that medication is not increased quickly enough or at high enough dosage to control the escalating signs of physiological hyperactivity.

2 Most sedative drugs used in palliative care act, at least in part, through modulation of higher cortical function. In the presence of profound cortical dysfunction, they are frequently ineffective even in

exceptionally high doses. Therefore, to achieve a state of 'calm coma' and a peaceful and dignified death:

a Appropriate escalation may need to be rapid and considerable and there is no reliable way of predicting who will develop these extreme responses.

b Intravenous administration may be required to achieve symptom control. However, this requires an appropriately skilled nursing team, which is usually only available in hospital settings.

Inexperienced physicians should not attempt to manage withdrawal of CANH without the support of a specialist team with direct experience in this area. In cases where this form of terminal care is initiated outside the specialist setting, back-up arrangements should be in place for immediate escalation of care without any delays waiting for funding or gaining 'agreement' from the specialist supporting team, should this become necessary.

Routes of administration

The enteral route does not provide reliable drug absorption because of gastric stasis. Moreover when enteric access is maintained there have been cases where well-meaning staff have covertly administered fluid or flushes. Therefore removal of the PEG is recommended at the start of withdrawal of CANH.

Sedation and anaesthesia should be given via a syringe driver, either through the subcutaneous (SC) or intravenous (IV) route.

- SC infusion is the usual mode of drug administration in palliative care. However, absorption is slower and less predictable than the IV route, and this may be a particular problem in profound dehydration.
- IV administration carries the advantage of predictability, especially as dehydration becomes more pronounced. It also provides a more immediate effect for boluses to cover interventions, such as oral hygiene.

Palliative care teams often prefer the SC route as it may be used both in hospital and community settings and helps to minimise medicalisation of the dying process. In the context of PDOC, however, the certainty that their loved one is not suffering as CANH is withdrawn is often uppermost in the family's mind. On this basis, they may even feel reassured by medicalisation and the presence of an IV infusion.

The choice of route therefore depends on the setting and the needs of the patient. SC infusion is often used to start with and may be adequate to support a peaceful death in some cases. However, for those who develop severe physiological hyperactivity, IV access may be needed to gain adequate control. This need may arise only in the later stages of profound dehydration but, by this time, hypovolaemia can make it difficult to gain reliable venous access. It is therefore recommended that secure venous access is established pre-emptively from the start via a peripherally inserted central catheter (PICC) or long venous line.

The use of IV medications may require proactive planning in liaison with the anaesthetic team and/or the hospital Drugs and Therapeutic Committee to ensure that all the requisite policies and procedures for IV administration are in place ahead of time.

Tables 5.2a, b and c provide the outline for a staged palliative care regimen. This is for guidance only and may be varied according to need.

- Table 5.2a outlines the principles and prerequisites for the palliative care regimen.
- Table 5.2b details a staged escalation for SC administration.
- Table 5.2c details the equivalent staged escalation for IV administration.

Table 5.2a. Principles and prerequisites of the palliative care regimen.

Arrangements	Ensure that:
	1 All staff are fully briefed and understand:
	a the principles of end-of-life care in this unusual situation
	b the expected duration and course of the dying process.
	2 All the necessary equipment (eg syringe drivers) and medications are available to deliver the regimens in Tables 5b and c.
	3 The family has been given information about what to expect and that arrangements are in place to support them, keep them informed and answer any questions that may arise.
	4 Arrangements are in place for:
	a regular medical review (several times a day if necessary, including out-of-hours advice)
	b active support from a specialist team or teams covering both neurological rehabilitation and palliative care.
	5 If starting outside a specialist environment, that funding and practical arrangements are in place to support escalation and transfer without delay, should this become necessary.
Prerequisites	1 Establish long-term IV access using PICC line or equivalent.
	2 Stop feeding and remove PEG tube.
	3 Review any medications for which the indications continue (eg antispasmodics) and consider the most suitable alternative route or replacement drug for these symptoms.
	4 If morphine and midazolam are considered appropriate replacement drugs, the starting doses in stage 1 may need to be adjusted accordingly.
	5 Start formal care pathway for the dying, according to local policy.
	6 Sedating medication may be given by SC or IV infusion via a syringe driver. If given SC, arrangements should be in place to transfer to IV administration if necessary.
Principles	1 Medication can either be given either:
	a SC with the use of a single infusion and SC boluses of the required drugs, or
	b IV with a separate infusion of each drug and IV boluses delivered from each infusion pump as required.
	2 Bolus doses (given SC or IV) may be used to assess the effect on unwanted signs and allow escalation of the effective medication.
	3 Medical staff should review medication at least 3–4 times per day to ensure adequate symptom relief and adjust the infusion dose according to the frequency of bolus doses required.
	4 Never decrease the background infusion dose, even when symptoms/signs appear to be well controlled.
	5 If the patient is not responding to bolus doses, they are either getting the maximum benefit from that drug or it is not being absorbed.
	• If still on SC regimen, give trial bolus of IV and transfer to IV infusion if a response is seen.
	• If already on IV and no response to IV bolus, proceed to next stage of protocol.

Table 5.2b. Staged escalation of palliative care regimen using SC administration.

Stage	Description	Escalation
Stage 1 Continuous SC infusion	**Set up a syringe driver and commence continuous SC infusion with:** • midazolam 10 mg/24 hours and • morphine 10 mg/24 hours.	
Bolus doses	1 Prescribe 2.5–5 mg SC prn bolus doses of each drug for management of signs/symptoms of physiological distress. 2 Nursing staff to administer the SC doses **and assess** if desired effect is achieved. • If no response after 15–30 min to initial bolus, repeat same dose. • If still no response after 30 min, double dose of bolus. • If no response after 30 min, repeat the double dose. 3 Bolus doses can also be given **prior to interventions** which provoke unwanted reflex activity.	
If requiring bolus doses and responding	Re-prescribe the total dose of each drug for the previous 24 hours* as the baseline continuous SC infusion up to maximum dose of 100 mg/24 hours midazolam and 150–200 mg/24 hours morphine.	If required, give further bolus SC doses, as needed. Double bolus doses may be tried for effect if single bolus gives suboptimum response.
No response to SC midazolam	• Convert to IV route **or** • progress to levomepromazine.	
Stage 2 Continuous SC infusion	**Add 50 mg levomepromazine to the current doses of midazolam and morphine in syringe driver**	
Bolus doses	Prescribe levomepromazine 12.5–25 mg for bolus SC doses. Nurses to follow plan as detailed above.	
If requiring bolus doses and responding	Re-prescribe the total dose for the previous 24 hours* as the baseline continuous SC infusion up to a ceiling dose of 150 mg/24 hours.	If required, give further bolus SC doses, as needed – usually 20 % of infusion rate.
No response to SC levomepromazine	If not responding at this stage, transfer to IV route is essential. See Table 5.2c. **Note: Stage 3 below may only be used as a holding strategy while IV access and/or transfer to an appropriate setting is arranged.** When changing to IV administration, the starting IV dose will usually be the subcutaneous regimen at the point of transfer.	
Stage 3 Continuous SC infusion	**Continue morphine and midazolam at current dose in first continuous SC infusion.** **Stop levomepromazine. Replace with 600 mg/day phenobarbitone in a second continuous SC infusion.**	
Stage 3 Bolus doses	Prescribe phenobarbitone 100–200 mg IM bolus doses. Nurses to follow bolus plan as detailed above.	
If requiring bolus doses	Re-prescribe the total dose for the previous 24 hours* as the baseline continuous SC infusion up to maximum dose of 1200 mg/24 hours.	

*If symptom control is not adequate and frequent boluses are required, the baseline infusion should be adjusted more frequently than every 24 hours.

Table 5.2c. Staged escalation of palliative care regimen using IV administration.

Stage 1 **Continuous IV** **infusion**	Medications are best loaded in separate syringe drivers so that they can be varied independently until the optimum regimen is established. **Set up two IV syringe drivers and commence IV infusion with:** • midazolam 10 mg/24 hours, and • morphine 10 mg/24 hours.
Bolus doses	Prescribe bolus IV doses of each drug to be given by the syringe pump: • 10 % of the 24-hour dose for short interventions • 20 % of the 24-hour dose for symptom control. Nursing staff to administer the IV bolus **and assess** if the desired effect is achieved, which should be evident within 5 minutes. • If no response to initial bolus repeat after 5–10 min. • If still no response after 2 doses, double the bolus dose. • If requiring 4 or more boluses/hour, increase the background infusion rate. Medical staff should review at least 3–4 times per day to ensure adequate symptom relief and adjust the infusion dose according to the frequency of bolus doses required up to: • midazolam 10–20 mg/hour • morphine 10 mg/hour. **In the large majority of cases, symptoms/signs should be controlled with these two drugs alone, providing adequate doses are given.** However, if no effect is seen from bolus doses, the patient is receiving the maximum benefit from these drugs. Progress to stage 2.
Stage 2 **Continuous IV** **infusion**	**Continue the current doses of morphine and midazolam in one IV syringe driver.** **Set up a second syringe driver with 50 mg levomepromazine/24 hours.**
Bolus doses	Prescribe bolus IV doses of levomepromazine 12.5–25 mg. Nurses to follow plan as detailed above. However, if no effect is seen from bolus doses, progress to stage 3.
Stage 3 **Continuous IV** **infusion**	**Continue morphine and midazolam at current dose in first continuous IV infusion.** **Stop levomepromazine. Replace with 600 mg/day phenobarbitone in a second continuous IV infusion.**
Bolus doses	Prescribe phenobarbitone 100–200 mg IV bolus doses. Nurses to follow bolus plan as detailed above. If not responding to bolus doses, proceed to stage 4.
Stage 4	**Self-ventilating anaesthesia** In very rare cases, severe physiological distress with terminal agitation may require self-ventilating IV anaesthesia. This should be administered with the support of ITU-trained staff under the supervision of a consultant anaesthetist.

Certification of death

When drawing up a death certificate after withdrawal of CANH, the original brain injury should be given as the primary cause of death. Depending on the cause of the brain injury, referral to the coroner may or may not be required. As cases of elective withdrawal of CANH are unusual and often emotive, the GDG recommends discussion with the coroner's officer either in advance or

immediately after death to determine whether referral is required or to agree the wording on the death certificate.

Suitable setting for end-of-life care

The setting for withdrawal of CANH requires careful consideration. When patients have been in long-term nursing home care, it is not uncommon for care teams to want to provide their end-of-life care as well. However, as noted above the challenges of this process should not be underestimated. In reality care staff often find it difficult to make the transition from a total caring role to withholding food and fluid. The intensity of input required makes home-based end-of-life care impractical in this context.

The requirement for rapid escalation, if necessary to IV medication (and on rare occasions anaesthesia), requires specialist palliative care medical and nursing expertise that is beyond the resources even of most hospice settings. Patients with PDOC also require management by care and nursing staff who are experienced in neuropalliative rehabilitation and the needs of patients with profound neurological disability.

We therefore recommend that elective withdrawal of CANH following Court approval should be organised by specialist rehabilitation and palliative care teams working closely together. The setting will depend upon individual circumstances including the wishes of the family and the current care team, the likelihood of the complications described above occurring, the experience of the current setting and team, access to specialist support and escalation. Sometimes admission to a highly specialist centre will be needed either before starting withdrawal or during the process, and currently a small number of such services exist and are building up experience in this unusual and challenging area of care.

If it is managed locally (eg in a hospice or nursing home setting) staff must ensure before starting the process of withdrawal that they will have access to specialist advice and support, from staff with specific expertise in this area. Also that commissioning arrangements are in place, in advance, to support the services of the community palliative care team or hospice *and rapid transfer to the specialist setting,* in the event that this is necessary. By the time the need arises it is usually urgent and it is clearly inappropriate to arrange transfer through standard emergency services, emergency departments etc.

Death by withdrawal of CANH is an emotive issue. Families considering the issue of withdrawing life-sustaining treatment for their loved one frequently ask questions that can be challenging to answer. Care teams sometimes ask similar questions. Box 5.3 contains some responses that may help clinicians to provide consistent information.

Box 5.3. Frequently asked questions and answers about withdrawal of CANH.

Families considering the question of withdrawing life-sustaining treatment for their loved one frequently ask questions that can be challenging to answer. The following FAQs may help clinicians to respond.

What will [name] die of?
Ultimately they die because they have a very severe brain injury and are unable to sustain their own food and fluid intake. Following withdrawal of CANH, the body has no source of fluid and the normal mode of death is by dehydration. With advanced dehydration, the circulating blood volume drops and there is build-up of toxic metabolites. This causes the failure of all the vital organs (heart, brain, kidneys, lungs).

How long will it take for [name] to die?
It is difficult to predict exactly, but experience suggests that for patients like [name] who die following withdrawal of CANH, death will usually occur within 2–3 weeks. Sometimes it is quicker (for example if they develop an intercurrent infection or seizures), but it is rarely longer than this.

Why must [name] die from deprivation of food and fluid – could he/she just have a quick lethal injection?
English law identifies a clear difference between withholding treatment that is considered futile (even though this will inevitably lead to death within a short period) and active killing by means of a lethal injection. Euthanasia is illegal under English law, and no doctor could prescribe or administer a lethal injection. However, with excellent palliative care and attention to detail we aim to ensure that [name] will not suffer in any way and will have as peaceful and dignified a death as possible.

Will [name] experience pain or suffering?
For patients in VS:
From studies of patients who die of dehydration but remain conscious, death by dehydration is relatively painless. In addition, so far as we can tell, [name] has no awareness of him/her self or anything around him/her and therefore will not suffer in any way. You may notice an increase in reflex behaviour (such as sweating, increased movements, moaning/groaning etc), which may give the impression that they are in pain. So in order that we can all be absolutely certain that they are not suffering we will prescribe strong sedative and pain relieving medication to keep them calm and allow them a peaceful and dignified death.

For patients in MCS:
This is a potential concern, although studies of patients who die of dehydration but remain conscious suggest that death by dehydration is relatively painless. Nevertheless, because they cannot readily communicate to tell us what they are experiencing, and in order to ensure that they are not suffering in any way, we will prescribe strong sedative and pain relieving medication to keep them calm and free from pain and discomfort. We will work very closely with the palliative care team to ensure that symptom control is optimised so that they can have a peaceful and dignified death.

[Name] has always carried a donor card – can his/her organs still be donated?
Unfortunately organ donation is not possible after withdrawal of CANH as the mode of death is through multi-organ failure secondary to dehydration, and the large majority of the relevant organs have been irreversibly damaged.

Section 5 End-of-life decisions and care: Summary of recommendations

	Recommendation	Grade
5.1	**Decisions regarding life-sustaining treatment and ceiling of care**	E1/2
	1 As part of clinical treatment planning for patients with serious illness or injury, the treating team should consider and document decisions regarding ceiling of care, including whether the patient would benefit from cardiopulmonary resuscitation (CPR) in the event of a cardiorespiratory arrest.	
	2 Like all treatment decisions for patients who lack mental capacity, decisions not to attempt cardiopulmonary resuscitation in the event of a cardiac arrest (DNACPR decisions) should be considered on the basis *of best interests*, based on the holistic balance of likely success, benefits and risks and harms as discussed in Section 4.	
5.2	**Do Not Attempt Cardiopulmonary Resuscitation (DNACPR) decisions**	E1/2
	1 Clinicians responsible for the care of patients with PDOC should be aware that:	
	a CPR in general has a very low success rate and may have harmful side effects including rib fracture, damage to internal organ, and hypoxic brain damage	
	b full-blown CPR procedures for cardiac arrest are unlikely to be successful in patients with profound brain injury, and even short periods of hypoxia are likely to lead to further brain damage and a worse clinical outcome	
	c for the large majority of cases, CPR represents 'futile' treatment for which the harms outweigh the benefits. It is usually clinically unjustified and inappropriate in patients with continuing PDOC.	
5.3	**Making DNACPR decisions**	E1/2
	1 DNACPR decisions should be considered as a matter of routine practice for patients with continuing PDOC.	
	2 The overall clinical responsibility for DNACPR decisions rests with the most senior clinician in charge of the patient's care but, wherever possible, should be agreed with the whole treating team.	
	3 After such a decision is made, a 'DNACPR form' should be used to communicate the decision to all those involved in the patient's care.	
	4 Distinction should be made between decisions to give or withhold CPR and other forms of emergency treatment, such as:	
	• a short reversible event, eg blocked tracheostomy tube or transient arrhythmia	
	• an acute infective episode	
	• other treatment, eg for seizures etc.	
	5 Advance instructions/treatment plans should be made distinctly and separately for each different circumstance.	
	6 Once a DNACPR decision and other specific instructions regarding treatment have been made, there should be a continuity of that decision across all settings including acute care, nursing home and ambulance transport, until and unless formally reviewed.	
	7 All DNACPR decisions should be reviewed at appropriate intervals, and should at a minimum form part of the annual review process.	
Discussion with family members		
5.4	**Informing family members**	E1/2
	1 If CPR is considered by the medical team to be a futile treatment, the clinician is under no obligation to offer it. It is nevertheless good practice to explain this to the family unless, in the clinician's view, this would cause undue distress.	
	2 If the doctor decides to make a DNACPR decision without discussion with the family, the reasons for this should be documented and it is wise to seek a second opinion from a consultant colleague.	

5.5 Normalising discussion of DNACPR decisions E1/2

1 Discussion of DNACPR decisions with the patient's family should be normalised so far as possible, by being conjoined with other prospective *best interests* decisions. This should ideally form part of the routine exchange of information at an early stage in the patient's admission.

2 Unless the family includes a Welfare Lasting Power of Attorney (LPA), whose terms of appointment expressly cover decisions about life-sustaining treatment, it should be made clear to the family that the decision of whether or not to undertake CPR in the event of a cardiac arrest lies with the doctors. The family are not being asked to give consent to the DNACPR, they are simply being asked about the patient's likely views and wishes.

3 Withdrawal of life-sustaining treatment

5.6 1 Withdrawal of life-sustaining treatment should be considered when further treatment is agreed to be futile. E1/2

- The majority of health and welfare decisions for a patient with PDOC (for example about managing intercurrent illnesses or attempted resuscitation), can be made under the MCA without involving the Court of Protection.
 (NB This does *not* apply to withdrawal of clinically assisted nutrition and hydration (CANH) – see 5.7 below.)
- Decisions can be made by the treating team in consultation with the family or any appointed authority (Welfare LPA, Welfare Deputy or IMCA) based on the patient's best interests.

2 All treatments are given on the basis of the patient's best interests, and doctors should weigh up the likely benefits and harms of each treatment given, in conjunction with family members/Welfare Deputy to determine the patient's likely views and wishes.

3 In general, treatments that are given to control symptoms and improve ease of care are appropriate.

4 Once it is deemed that recovery to a condition that offers what the patient would have considered reasonable quality of life is unlikely, then it is usually appropriate to withdraw/ withhold life-sustaining treatments such as:

a prophylactic agents, such as thromboprophylaxis, statins etc

b antibiotics for life-threatening infections.

5.7 Withdrawal of clinically assisted nutrition and hydration (CANH) E1/2

In English and Welsh law, a decision to withdraw CANH in patients with PDOC cannot be made by clinicians alone but must be referred to the Court of Protection, for a judge to make the decision. This applies even in cases of permanent VS where the patient has a valid and applicable Advance Decision to Refuse Treatment (ADRT). In this situation, the decision may be a simple and rapid one, but the Court will always wish to scrutinise the validity of the ADRT.

1 Court applications for withdrawal of CANH under the appropriate circumstances, as laid out in these guidelines, should normally be a state responsibility.

a They should not be left up to the family.

b The legal costs of the *bests interests* meeting and any subsequent Court application/ proceedings should be borne by the responsible health authority (ie clinical commissioning group (CCG)).

c Responsibility for initiating the application should lie with the treating clinical organisation, but is funded by the service commissioners.

5.8 Outline of procedure for applying for withdrawal of CANH in patients in VS E1/2

When a patient is diagnosed as being in a permanent VS, further treatment is considered futile. Once it is known that a patient is in a permanent VS, processes to consider and withdraw all life-sustaining treatments, including CANH, should begin on the grounds of their best interests.

Within 4 weeks of the diagnosis of a permanent vegetative state, a formal *best interests* meeting should be convened between the treating team, the family and the responsible health authority to decide whether continuing life-sustaining treatment remains in the patient's best interests.

If and when it has been decided that continuation of CANH is not in the patient's best interests, the treating team should inform the funding commissioning organisation in order to identify who will instruct lawyers to approach the Court of Protection with an application to withdraw CANH.

Funding of the application should be the responsibility of the NHS, and provided by the service commissioners.

Please refer to Section 5 (Box 5.2) for operational procedures for application for withdrawal of CANH in patients with permanent VS or MCS.

5.9 **Outline of procedure for applying for withdrawal of CANH in patients in MCS** E1/2

The diagnosis of 'permanent MCS' is less well defined. However, Section 1 proposes time points after which emergence to consciousness may also be considered highly improbable. For patients remaining in MCS beyond these time points, it is legitimate to consider whether withdrawing all life-sustaining treatments, including CANH, would be in their best interests.
- The presence of some degree of awareness does not prevent applications to the Court for withdrawal of CANH.
- Clinicians should consider this option as part of *best interests* decision-making, especially where there is valid evidence that the patient would not want to continue living in their current condition and that continued CANH may not be in their best interests considering the benefits and burdens of treatment.

When a patient is diagnosed as being in permanent MCS, there should be a formal *best interests* decision-making meeting between the treating team, the family and the responsible authority (eg CCG) to decide whether it is appropriate to continue life-sustaining treatments, based on the balance of *best interests* – including whether it is appropriate to make an application to the Court for withdrawal of CANH, based on the balance of *best interests*.

5.10 **The general public** E1/2
1 The general public can also assist by giving consideration to their wishes in this respect as they draw up any advance care planning documents such as:
 a an LPA that appoints a Welfare LPA with authority to make healthcare decisions on their behalf, or
 b an Advance Decision to Refuse Treatment (ADRT).

5.11 **Clinicians** E1/2
1 Clinical staff should be supported in knowing that withdrawal of CANH removes an impediment to death: it neither causes it, nor do they carry a moral responsibility for the death that follows and they are not culpable.

5.12 **Conscientious objection** E1/2
1 Clinicians should be aware that any strongly held personal views and beliefs are a potential source of conflict of interest, which must be declared.
2 If the individual clinician cannot sanction a *best interests* decision in one direction they should hand over the care of the patient to a clinician who can.
3 If an institution providing care for a patient being considered for withdrawal of CANH does not support or allow withdrawal, then they should state this publicly and inform the family and the commissioning organisation *before* admission. They must:
 - arrange for independent collection and collation of diagnostic data (if needed)
 - allow an independently run *best interests* meeting
 - facilitate transfer to another organisation if needed – either during the decision-making and legal process, or if a decision to allow withdrawal has been agreed.

End-of-life care for patients with PDOC

5.13 1 End-of-life care for patients dying in VS/MCS should be managed using a team-based approach with close coordination between specialists in palliative care and neurodisability management. E1/2

2 Patients dying in PDOC should be managed in centres with experience in the management of complex neurological disability, or in specialist nursing homes, supported by staff with the appropriate skills and knowledge of PDOC.

3 These sites must have access to specialist palliative care services.

5.14 **Care of the dying patient following withdrawal of CANH** E1/2

The elective withdrawal of CANH poses some particular challenges as outlined in Section 5.

1 Even if it is felt that the patient is not capable of experiencing emotions, feelings or symptoms, behaviours that might indicate distress should be managed proactively to reassure family and care staff that the patient is not suffering.

2 The team should be prepared to manage unpredictable and clinical instability.

a Elective establishment of secure intravenous access by insertion of a PICC (peripherally inserted central catheter) or other long line is recommended.

3 Staff should be aware of the particular challenges of managing patients dying from withdrawal of CANH.

a The dying process can be prolonged – often taking 2–3 weeks.

b As a result of the physiological and biochemical changes associated with dehydration and catabolism, patients may show signs of 'physiological distress' (heighted autonomic and reflex activity), which may give the appearance that they are aware and experiencing distress.

c Even though the patient him/herself may be unaware, this physiological distress poses a burden of witness for families and staff caring for the patient, and so may be a focus for intervention in its own right.

d As most sedative drugs act through modulation of higher cortical function, high doses may be required to achieve the same effect in severe cortical dysfunction.

e Appropriate escalation is required in a timely manner until a state of 'calm coma' is achieved to allow a peaceful and dignified death.

f Specialised anaesthetics may rarely be required and these can only be given intravenously and monitored in a specialist centre.

5.15 **Specialist centres for management of elective withdrawal of CANH** E1/2

1 Given the rarity of these cases, and the challenges for management outlined above, withdrawal of CANH should usually be managed by (or at minimum in liaison with) specialist teams.

2 Such services should be equipped to offer a round-the-clock approach to management, including close collaboration between the specialist palliative care and neurodisability teams. Essential features of the clinical care support that should be available during the withdrawal process include:

a 24-hour dedicated nursing care and on-site medical support to provide competent care of the neurological patient, including IV medication

b 24-hour access to specialist palliative care support and anaesthetic backup

c requisite skills capable of managing regimes of major central neurological depressants – including intravenous medication where required

d access to anaesthetic support for self-ventilating anaesthesia, for the rare occasions when this is required

e specialist support for family, including overnight accommodation.

5.16 Local management

1 In certain situations there may be a justifiable preference to keep someone in their locality. In this case, commissioners and senior clinical staff responsible for the patient should ensure that the treating team is fully aware of the challenges listed in 5.14 above and has plans to manage them, including access to specialist advice from a clinician with direct experience in this area.

2 Backup plans must be in place for urgent transfer to a specialist centre should circumstances necessitate this.

Section 6
Service organisation and commissioning

1 Background and policy framework in England

The National Service Framework (NSF) for Long Term neurological Conditions, published in 2005,[81] emphasised the need for specialist services for people with profound and complex disability. It recommended that rehabilitation services should be planned and delivered through coordinated networks, in which specialist neurorehabilitation services work in both hospital and the community to support local rehabilitation and care support teams. Quality Requirement 1 of the NSF specifies the requirement for lifelong care with integrated care planning with at least annual review for patients with complex needs.

In 2006, the Carter report[108] highlighted the need for high-cost/low volume 'specialised services' to be planned over a suitable geographical area (approximately 1–3 million population), so requiring collaborative commissioning arrangements.[109] In 2009 the Department of Health drew up a national definition set of specialised services. 'Brain injury and complex rehabilitation' was definition No 7 within this set.[109]

Following the Health and Social Care Act 2012,[110] responsibility for commissioning of 'prescribed' specialised services transferred to the national NHS Commissioning Board (now 'NHS England'). All other specialist and general services are commissioned at local level by clinical commissioning groups (CCGs).

Under these new commissioning arrangements, 'Specialised rehabilitation for patients with highly complex needs' replaces the previous definition 'Brain injury and complex rehabilitation' for nationally commissioned specialised services, but has a similar scope.

This specialised service specification includes neuropalliative rehabilitation for patients with profound or total disability, including patients in vegetative or minimally conscious states.

2 Organisation of services – a network model

Certain aspects of management of PDOC require highly skilled specialist trained staff. These highly specialist elements include:

- coordinated assessment and management of highly complex physical, cognitive, sensory and communication disorders, including decannulation and respiratory management in long-term tracheostomy
- expert assessment and diagnosis of VS and MCS, including the application of formal diagnostics tools, such as the WHIM, CRS-R and SMART
- organising specialist equipment (eg special seating, electronic assistive technology where appropriate) and the ongoing care and rehabilitation programme
- support for end-of-life care – especially where CANH is electively withdrawn following a *best interests* decision by the court (see Section 5).

Highly trained rehabilitation professionals are in short supply in the UK, and it is not feasible or economical to duplicate these high cost/low volume services in every locality.

To deliver the pathway of care outlined in Section 3, service provision will need to follow a network model with centralisation of key skills in 'specialised' centres. However, those staff should also work in an outreach capacity to support local teams in the longer-term rehabilitation, care and support of PDOC patients in settings that are closer to the patients' own home and family.

Within this network model:
- Experienced multidisciplinary teams in the specialist PDOC neurorehabilitation services provide the highly specialist elements of the pathway, as described above. The teams also provide outreach support to local slow-stream rehabilitation and long-term care services. In England, these tertiary services are commissioned nationally by NHS England through the specialised services framework.
- Slow-stream rehabilitation and ongoing assessment in the first year after injury is provided closer to the patient's own home and family. This should contain the elements highlighted in Section 3. The programme of care is commissioned by local healthcare commissioners (CCGs) under the NHS Continuing Care programme with advisory support from the outreach specialist team as needed.
- Long-term care and support for patients with PDOC in the specialist nursing home (or rarely in the patient's own home) is also provided through the NHS Continuing Care services. This should include annual review by the tertiary specialised neurorehabilitation team:
 - to monitor for any significant change in the level of responsiveness or clinical condition
 - to give advice and support for any *best interests* decisions, including those to withdraw life-sustaining treatments if this becomes appropriate.
- Neuropalliative and end-of-life care for patients in PDOC requires a collaborative approach from both palliative care and neurorehabilitation teams.
 - The majority of patients die through naturally occurring intercurrent conditions (eg chest infections etc). End-of-life support under these circumstances should be commissioned locally by the CCGs.
 - As noted in Section 5, elective withdrawal of CANH following *best interests* decisions by the Court poses some particular challenges and is best managed in designated specialist centres. This should be commissioned centrally by NHS England.

3 Organisation and commissioning of services for assessment and diagnosis

Specialist PDOC neurorehabilitation service

Assessment, diagnosis and ongoing monitoring of patients with PDOC should be undertaken by specialised centres, designated as Level 1 or 2a services and commissioned by NHS England. There should be at least one such service in every clinical senate.

Designated centres are responsible for maintaining appropriately trained specialist staff, experienced in diagnosis and management of patients with PDOC, trained in application of the various approved validated tools for assessment, and familiar with the information requirements of the minimum dataset.

The designated centre should be responsible for diagnosis, registration and ongoing monitoring of patients with PDOC in conjunction with their local teams.

Assessment/reviews may be undertaken in the centre or in the patient's home/placement according to patient need. The centre is also responsible for training staff in local centres, eg nursing homes, to recognise localising/discriminating behaviours and to use tools such as the WHIM, CRS-R etc to inform monitoring and identify any change in the level of responsiveness that may occur over time.

Nursing home and slow-stream rehabilitation

Whether on the basis of interim placement or long-term care, patients with VS and MCS should be managed under the NHS Continuing Care arrangements.

As noted in Section 3, commissioners should be aware that the care package must include an appropriate maintenance therapy programme to manage the patient's ongoing needs, including:
- physical care – spasticity management, prevention of contractures, tracheostomy management, enteral feeding, opportunities for oral feeding etc
- an appropriate programme of stimulation and opportunities for social activities
- where necessary, support for communication and interaction, including the provision of appropriate communication or environmental control aids and training for care staff to provide opportunities for interaction
- training for staff to use tools such as the WHIM as a framework to record any observed responses.

Home care

As noted in Section 3, patients with PDOC have very intensive and specialist care requirements and it is rarely feasible or practical to provide care in the home setting.

In certain circumstances – in particular where one of more family members are dedicated to providing the role of lead carer – it may be appropriate to provide a home-based support package, which may be provided through NHS Continuing Care or via a personal healthcare budget. Patients with VS and MCS are potentially vulnerable and such home care arrangements should be subject to risk assessment and adequately supported by a case manager, to ensure that care staff are adequately trained to manage patients' complex needs.

4 Current levels of provision

The GDG recognises that current levels of provision and organisation of services fall considerably short of the recommendations included in this guidance, and do not provide an orderly progression through the care pathway.

The following aspects are identified as particular problems:

1 Due to inadequate bed capacity in the specialist neurorehabilitation centres, some patients are often repatriated from acute neurosciences centres or major trauma centres back to their local district service (which does not have the skills or facilities to manage their needs) until they can be transferred to an appropriate assessment centre. Here patients not uncommonly develop complications such as contractures and pressure sores which can add to their length of stay when they reach the specialist centre.

2 Special seating is critical to making an accurate diagnosis, but is usually provided through local special seating services who may:

a refuse to assess the patient until they go home or into a long-term placement, or

b have a slow turnaround for seating provision, and

c may offer only a limited range of seating options.

The timely provision of appropriate specialist seating was highlighted by the GDG as an important area for recommendation.

The guidelines therefore make recommendations that cannot be delivered within current resources. Some concerns were expressed that they single out patients with PDOC for a level of management that other patients with less severe brain injuries cannot access, even though they may have greater potential for longer-term benefit. This is justified on the basis of the vulnerability of the patients and the degree of family distress. In the longer term, streamlining of assessment and early direction down appropriate care pathways has some potential to generate cost savings within the acute care services.

5 Research and development

Further research and development is needed to improve our understanding of PDOC, including:

- the role of functional imaging and electrophysiology
- longitudinal evaluation of outcomes through cohort analysis to identify:
 - long-term prognosis and survival
 - factors that determine prognosis
- economic evaluation to identify cost-effective models of care
- exploration of patient and family perspectives to provide a better understanding of the ethical issues governing *best interests* decisions for life-sustaining treatments
- data collection on national experience of the clinical process of withdrawal of CANH, to help develop appropriate approaches to palliative care and the optimum regimens to manage end-of-life care within different care settings.

Section 2 recommends the establishment of a national register and agreed minimum dataset for the collection of a national cohort of longitudinal outcome data for patients in PDOC.

The UK Rehabilitation Outcomes Collaborative (UKROC) has established a national database for specialist rehabilitation services that incorporates the inpatients rehabilitation dataset from the NHS

Information Centre's dataset for long-term neurological conditions (LTNC dataset).[111] As this represents the only longitudinal database for systematically collating data from patients with complex needs in the UK at the current time, the GDG recommends that the proposed database for PDOC should be incorporated within the UKROC national clinical database.[112]

This will require modest investment for database development, and it is envisaged that the (modest) cost of ongoing maintenance will need to be built into commissioning arrangements.

Section 6 Service organisation and commissioning: Summary of recommendations

	Recommendation	Grade
6.1	**Designated specialist services**	E1/2
	1 There should be at least one designated specialist service for assessment of PDOC in each of the 12 clinical senates in England.	
	2 Designated centres should have appropriately trained specialist staff who are:	
	a experienced in diagnosis and management of patients with PDOC	
	b trained in the application of the approved validated tools for assessment	
	c familiar with the information requirements of the minimum dataset.	
6.2	**Role of the designated services**	E1/2
	1 The designated centre should be responsible for diagnosis, registration and ongoing monitoring of patients with PDOC in conjunction with their local teams.	
	2 Assessment/reviews may be undertaken in the centre or in the patient's home/placement according to the patient's circumstances.	
	3 The centre is also responsible for training staff in local centres, eg nursing homes, to recognise localising/discriminating behaviours and to use tools such as the WHIM, CRS-R etc.	
6.3	**Commissioning services for patients in PDOC**	E1/2
	1 Assessment, monitoring and review of PDOC should be commissioned by NHS England under the national commissioning arrangements for specialised rehabilitation for patients with highly complex needs.	
	2 Commissioning arrangements should be in place to ensure timely provision of appropriate seating to maximise opportunities for interaction.	
	3 After formal diagnosis and initial review, patients in PDOC (VS or MCS) who are discharged from the specialist neurorehabilitation services should automatically qualify for fully funded NHS Continuing Care commissioned locally, until such time as they either die or emerge from PDOC.	
	4 Commissioning arrangements should include annual review by staff from specialist centres to monitor any changes in the patient's level of responsiveness.	
6.4	**National register and database**	E1/2
	1 There should be a national register and an agreed minimum dataset for the collection of a national cohort of longitudinal outcome data for patients in PDOC.	
	2 All patients who are in VS or MCS at the end of their initial assessment at 3 months post onset/injury should be entered into the register, and reviewed at least annually until they either die or emerge from PDOC.	
	3 The database should be incorporated within the UK Rehabilitation Outcomes Collaborative (UKROC) national clinical database for specialist rehabilitation.	
6.5	**Elective readmission**	E1/2
	1 Following a period of consolidation in the community, a patient may require readmission to formal inpatient neurorehabilitation if any of the following occur:	
	a There is improvement in the patient's level of responsiveness to an extent where s/he would benefit from a specialist goal-orientated rehabilitation programme.	
	b The placement proves to be unable to meet the care needs satisfactorily, requiring care needs to be redefined and a suitable alternative found.	
	c A specific problem arises that requires admission for disability management (eg severe spasticity, marked postural difficulties, skin pressure ulceration) or medical/surgical management.	
	d The patient reaches a critical time point for diagnosis and decision-making and requires a short admission to assess formally the level of awareness and to confirm permanence (or otherwise) (eg for the purpose of applications to the Court of Protection for consideration of withdrawal of CANH).	

6.6 ***Best interests* decisions regarding withdrawal of CANH** E1/2

1 When patients are diagnosed as being in permanent VS or MCS, local health commissioners (ie CCGs) should be kept informed of any *best interests* meetings to consider the appropriateness of application to the Court of Protection for withdrawal of CANH.

2 If it is decided that a Court application for withdrawal of CANH is in the patient's best interests, the commissioners should work with the treating team to identify who will instruct lawyers to prepare the application, but funding for the application will be the responsibility of the service commissioners.

6.7 **Managing withdrawal of CANH** E1/2

Given the rarity of these cases, and the particular challenges for management following elective withdrawal of CANH, adequate care is usually best provided in (or with support from) specialist units, as noted in Section 5.

1 Commissioners should ensure that:

a adequate commissioning arrangements are in place to support withdrawal of CANH by or in specialist centres

b where local management of withdrawal can be justified, there is adequate access to specialist advice, and backup arrangements are in place should circumstances change.

2 Local commissioners should therefore be involved in these cases from the earliest possible stage to secure the necessary funding, including emergency escalation plans to move to a specialist centre should this be required.

Appendix 1
Details of methodology

Evidence gathering

No dedicated funding or resources were available for the assimilation of evidence. It was therefore not possible to undertake full systematic literature evaluation for every aspect of the guideline. Literature searching, review and appraisal was provided by members of the GDG, who were selected for their specialist knowledge and familiarity with the key literature in this area. The RCP library provided IT support for updated searches, and GDG members were asked to save their search strategies for any literature searches conducted. Date parameters were selected as appropriate to the subject. For example, the term 'vegetative state' was defined in this context in 1972, whilst minimally conscious state was defined in 2002. Therefore the search terms limited the data parameters for the search, but otherwise no specific date limits were set.

Evidence was evaluated and assimilated using the typology that was developed to underpin the recommendations in the National Service Framework (NSF) for Long Term neurological Conditions.[2] This typology was chosen because it supports the assimilation of a wide range of evidence including quantitative and qualitative research, and professional and user opinion. It is recommended by the RCP when a broad base of evidence is anticipated.[113]

The NSF typology

Within the typology, each piece of evidence is given an 'R' (Research) or an 'E' (Expert) rating.

Research evidence

Evidence gathered through formal research processes is categorised on three levels:
- design
- quality
- applicability.

Design

Primary research-based evidence	
P1	Primary research using quantitative approaches
P2	Primary research using qualitative approaches
P3	Primary research using mixed methods (qualitative and quantitative)
Secondary research-based evidence	
S1	Meta-analysis of existing data analysis
S2	Secondary analysis of existing data
Review-based evidence	
R1	Systematic reviews of existing research
R2	Descriptive or summary reviews of existing research

Quality assessment

Each quality item is scored as follows: Yes = 2; In part = 1; No = 0.

	Scoree
Are the research question/aims and design clearly stated?	
Is the research design appropriate for the aims and objectives of the research?	
Are the methods clearly described?	
Are the data adequate to support the authors' interpretations/conclusions?	
Are the results generalisable?	
Total (*High = 7–10; Medium = 4–6; Low = 0–3*)	**/10**

Applicability

Applicability to the field of disorders of consciousness:
- **Direct** – ie evidence from the population of patients with DOC
- **Indirect** – ie extrapolated evidence from a different population/condition.

Each referenced article is categorised in these three terms. For example, a high-quality study reporting quantitative data from patients with DOC would be categorised '**P1 High Direct**'.

Expert evidence

Expert evidence is that expressed through consultation or consensus processes rather than formal research designs. It may come from service users (eg families or carers of patients with PDOC) or from professionals. Published expert opinion may come from existing reports, guidelines or consensus statements.

In the absence of formal research or published expert opinion to underpin the guidance, recommendations were developed through an iterative process of drafting and discussing the recommendation statements until consensus was reached within the GDG. In the event of opposing views which could not be resolved through discussion, both viewpoints are presented with their supporting argument to represent the range of opinion.

Assimilation of evidence to underpin recommendations

Each recommendation has the following ratings according to the strength of supporting evidence

Grade of evidence	Criteria
Research evidence	
RA	• More than one study of high quality score (\geq7/10) *and* • At least one of these has direct applicability
RB	• One high quality study *or* • More than one medium quality study (4–6/10) *and* • At least one of these has direct applicability *or* • More than one study of high quality score (\geq7/10) of indirect applicability
RC	• One medium quality study (4–6/10) *or* • Lower quality (2–3/10) studies *or* • Indirect studies only
Expert evidence	
E1	User and/or carer opinion
E2	Professional or other stakeholder opinion

Research undertaken specifically for this guideline

A number of studies were undertaken specifically to underpin this guideline.
- A postal survey of the British Society of Rehabilitation Medicine membership was conducted to ascertain current practice and approaches to management of patients with PDOC (currently in preparation for publication).
- Analyses of existing data from WHIM and SMART assessments were performed (Delargy *et al*).[41]
- The guideline also drew extensively on a series of detailed qualitative interviews with the families of patients in VS and MCS, conducted by Jenny Kitzinger and Celia Kitzinger.[86]

Meetings and rules of engagement for GDG members

The guidelines were developed over the course of an 18-month period from December 2011 to June 2013. Three all-day meetings of the GDG were held in London, in December 2011, April and September 2012.

Meetings were conducted with the full GDG, supported by three subgroups with co-opted members to work on specific aspects of the guidelines.

GDG members were expected to make a balanced contribution, taking into account the available evidence/range of views in that area, rather than simply adhering to their own individual viewpoint.

Meetings were conducted in confidence.

GDG members were allowed to discuss issues with their multidisciplinary teams in order to seek a balanced view to present to the group. However, they were asked not to share preliminary drafts or other information circulated during the preparation of the guidelines, or to speculate with others about the content/recommendations.

Appendix 2
List of electronic annexes

The following electronic annexes provide additional details and practical tools, and are available online only at **www.rcplondon.ac.uk/pdoc**.

Section 1	
1a	Parameters for evaluation of reliable and consistent responses in patients emerging from MCS
1b	Summary of the literature on prognosis for recovery

Section 2	
2a	Full formal clinical assessment of people with PDOC
2b	Minimum requirements for experience and training of assessors for patients with PDOC
2c	Optimising conditions for response
2d	Comparison of the WHIM, CRS-R and SMART tools
2e	Checklist of features for families and care staff to look for
2f	Formal evaluation and record of diagnosis of VS or MCS

Section 3	
3a	The clinical management of people with PDOC

Section 4	
4a	Best interests checklist for patients with PDOC
4b	Serious medical decisions regarding people in vegetative or minimally conscious states: the role of family and friends
4c	Template for an Advance Decision to Refuse Treatment (ADRT)

Appendix 3
Glossary

Acronym	Stands for	Explanation/definition
BSRM	British Society of Rehabilitation Medicine	The UK professional society for rehabilitation medicine
ADRT	Advance Decision to Refuse Treatment	A decision made in advance to refuse a specific type of treatment at some time in the future. It must be written down, signed by the individual and witnessed
AGREE	Appraisal of Guidelines for Research and Evaluation	The AGREE Collaboration published standards for the development of clinical guidelines
ANH	Artificial nutrition and hydration	The provision of artificial nutritional and fluid support by means of 'tube feeding' (see under CANH)
BCI	Brain–computer interface	A direct communication pathway between the brain and an external device
CANH	Clinically assisted nutrition and hydration (previously known as artificial nutrition and hydration (ANH)).	The provision of nutritional and fluid support by means of 'tube feeding', eg given either enterally (via a nasogastric or gastrostomy tube) or parenterally (via an intravenous line)
CCGs	Clinical commissioning groups	NHS organisations that organise and commission the delivery of local NHS services in England
CEEG	Core Executive and Editorial Group	The subgroup of the committee responsible for progressing the draft PDOC guidelines in between meetings
CEP	Cognitive evoked potentials	Electrical activity in the brain in response to cognitive stimuli
CPR	Cardiopulmonary resuscitation	An emergency lifesaving procedure that is done when someone's breathing or heartbeat has stopped in an attempt to restore circulation and spontaneous respiration
CRS-R	The JFK Coma Recovery Scale – Revised	A 25-item hierarchically arranged clinical assessment scale to evaluate the level of responsiveness in PDOC
CT	Computerised tomography	A method of imaging that uses a computer to construct detailed cross-sectional images of various parts of the body from X-rays
DISCs	Depression Intensity Scale Circles	A visual analogue scale designed to facilitate reporting of depression in patients with communication and cognitive deficits

DNACPR	Do Not Attempt Cardiopulmonary Resuscitation	A decision made in advance not to attempt CPR in the event of a cardiorespiratory arrest
DOC	Disorder of consciousness	A state of diminished or absent responsiveness/awareness
DOCS	Disorders of Consciousness Scale	A clinical assessment scale to evaluate the level of responsiveness in PDOC
DTI	Diffusion tensor imaging	An MRI method which supports mapping of the diffusion process of molecules, to allow detailed visualisation of tissue architecture and the neural tracts
EEG	Electroencephalography	A test that records and measures electrical activity in the brain
EOL	End of life	The period towards the end of a person's life when they have a terminal condition and the focus of healthcare is on managing a good quality death
fMRI	Functional magnetic resonance imaging	A functional neuroimaging procedure that uses MRI technology to measure brain activity by detecting changes in blood flow associated with various cognitive or motor tasks
GCS	Glasgow Coma Scale	A simple clinical assessment scale to evaluate the level of consciousness
GDG	Guideline Development Group	The working party of professionals who developed these guidelines
IMCA	Independent Mental Capacity Advocate	A statutory advocate who represents people who lack capacity to make decisions about serious medical treatment and change of accommodation, where they have no family and friends available for consultation about those decisions
IV	Intravenous	A route of administration of drugs or fluid by injection directly into a vein
LPA	Lasting Power of Attorney	A Lasting Power of Attorney is a legal document which allows people aged 18 or above to make appropriate arrangements for family members or trusted friends to be authorised to make decisions on their behalf
MCA	Mental Capacity Act 2005	The Act of UK Parliament applying to England and Wales, which provides the current legal framework for acting and making decisions on behalf of adults (over 16 years old) who lack capacity to make particular decisions for themselves
MCS	Minimally conscious state	A state of wakefulness with minimal awareness characterised by inconsistent, but reproducible, responses above the level of spontaneous or reflexive behaviour
MRI	Magnetic resonance imaging	A method of imaging that uses strong magnetic fields and radio waves to produce cross-sectional images of organs and internal structures in the body
NG	Nasogastric	A route of administration where a tube is inserted through the nose and into the stomach – in this context to administer enteral feeding
NHS	National Health Service	A system of four publicly funded healthcare systems within the UK, providing health services for residents of the UK
NHSE	NHS England	The national board that oversees commissioning of healthcare services in England and directly commissions specialised services

NICE	National Institute for Health and Care Excellence	A UK body that provides national guidance and advice to improve health and social care
NSF for LTNC	National Service Framework for Long Term neurological Conditions	A set of 11 quality requirements, published by the Department of Health in 2005, that sets standards for the care of patients with long-term neurological conditions in England
PAIN-AD	Pain Assessment in Advanced Dementia	An assessment tool for recording pain-related behaviours in patients who cannot communicate their symptoms
PDOC	Prolonged disorders of consciousness	A state of diminished or absent responsiveness/awareness persisting for more than 4 weeks following sudden onset profound acquired brain injury
PEG	Percutaneous endoscopic gastrostomy	A tube inserted through the abdominal wall into the stomach under endoscopic guidance to administer enteral feeding
PET	Positron emission tomography	A nuclear imaging technique that produces a three-dimensional image or picture of functional processes in the body by detecting gamma rays emitted from a radioactive tracer, introduced into the body on a biologically active molecule
PICC	Peripherally inserted central catheter	A form of intravenous access that can be used for a prolonged period of time. A PICC is inserted in a peripheral vein and then advanced through increasingly larger veins, toward the heart until the tip rests in the distal superior vena cava
RCP	Royal College of Physicians of London	The professional body of doctors of general medicine and its specialties in England and Wales
REM	Rapid eye-movement (sleep)	A normal stage of sleep characterised by the rapid and random movement of the eyes
SC	Subcutaneous	A route of administration of drugs or fluid by injection under the skin
SDSS	Signs of Depression Scale	A brief screening tool to record behaviours that may be associated with low mood in patients who are unable to report their symptoms
SEP	Sensory evoked potentials	Electrical activity in the brain in response to sensory stimuli
SMART	The Sensory Modality Assessment and Rehabilitation Technique	A detailed clinical assessment and treatment tool developed to detect awareness, functional and communicative capacity in PDOC
SMART-INFORMS	The informal component of the SMART	A questionnaire to obtain information from family and carers regarding observed behaviours and pre-morbid interests, likes and dislikes, as part of the SMART assessment
SPIN	Scale of Pain Intensity	A visual analogue scale designed to facilitate pain reporting for patients with communication and cognitive deficits
SSAM	Sensory Stimulation Assessment Measure	A clinical assessment scale to evaluate the level of responsiveness in PDOC
UKROC	UK Rehabilitation Outcomes Collaborative	A programme that holds the national clinical database systematically recording data on needs, inputs and outcomes for all Level 1 and 2 specialist rehabilitation services in England
UWS	Unresponsive wakefulness syndrome	A term used by the European Task Force on Disorders of Consciousness to replace 'vegetative state'

VS	Vegetative state	A state of wakefulness with absent awareness, characterised by complete absence of behavioural evidence for self- or environmental awareness.
Welfare LPA	The donee of a 'Health and Welfare Lasting Power of Attorney'	A named individual appointed through an LPA to make decisions about health and welfare on behalf of someone else when the person him/herself no longer has capacity
WHIM	The Wessex Head Injury Matrix	A clinical assessment scale consisting of a 62-item hierarchical scale to monitor an individual's level of responsiveness and interaction with their environment following brain injury
WNSSP	Western Neuro Sensory Stimulation Profile	A clinical assessment scale to evaluate the level of responsiveness in PDOC

References

1 Royal College of Physicians. *The vegetative state*. London: RCP, 2003.

2 Turner-Stokes L, Harding R, Sergeant J *et al*. Generating the evidence base for the National Service Framework (NSF) for Long Term Conditions: a new research typology. *Clin Med* 2006;6:91–7.

3 Appraisal of guidelines for research and evaluation. London: The AGREE Collaboration, 2001.

4 Laureys S, Celesia GG, Cohadon F *et al*. Unresponsive wakefulness syndrome: a new name for the vegetative state or apallic syndrome. *BMC Med* 2010;8:68.

5 Giacino JT, Kalmar K. Diagnostic and prognostic guidelines for the vegetative and minimally conscious states. *Neuropsychol Rehabil* 2005;15:166–74.

6 Bauby JD. *The Diving Bell and the Butterfly*. Leggatt J, editor. New York: Knopf, 1997.

7 Giacino JT, Ashwal S, Childs N *et al*. The minimally conscious state: definition and diagnostic criteria. *Neurology* 2002;58:349–53.

8 Bruno MA, Vanhaudenhuyse A, Thibaut A *et al*. From unresponsive wakefulness to minimally conscious PLUS and functional locked-in syndromes: recent advances in our understanding of disorders of consciousness. *J Neurol* 2011 Jul;258:1373–84.

9 Nakase-Richardson R, Yablon SA, Sherer M *et al*. Serial yes/no reliability after traumatic brain injury: implications regarding the operational criteria for emergence from the minimally conscious state. *J Neurol Neurosurg Psychiat* 2008;79:216–8.

10 Nakase-Richardson R, Yablon SA, Sherer M *et al*. Emergence from minimally conscious state: insights from evaluation of posttraumatic confusion. *Neurology* 2009 Oct 6;73:1120–6.

11 Di Stefano C, Masotti S, Simoncini L *et al*. Context-dependent responsiveness in patients with severe disorders of consciousness after brain injury. *Brain Inj* 2010;24:275.

12 Wilson SL, Powell GE, Brock D *et al*. Vegetative state and responses to sensory stimulation: an analysis of 24 cases. *Brain Inj* 1996;10:807–18.

13 The Multisociety Taskforce report on PVS: Medical aspects of the persistent vegetative state, Part 1 and 2. *New Eng J Med* 1994;330:1499–508,572–9.

14 Giacino JT, Kalmar K. The vegetative and minimally conscious states: A comparison of clinical features and outcome. *J Head Trauma Rehabil* 1997;12:36–51.

15 Luaute J, Maucort-Boulch D, Tell L *et al*. Long-term outcomes of chronic minimally conscious and vegetative states. *Neurology* 2010;75:246–52.

16 Estraneo A, Moretta P, Loreto V *et al*. Late recovery after traumatic, anoxic, or hemorrhagic long-lasting vegetative state. *Neurology* 2010 Jul 20;75:239–45.

17 Lammi MH, Smith VH, Tate RL *et al*. The minimally conscious state and recovery potential: a follow-up study 2 to 5 years after traumatic brain injury. *Arch Phys Medic Rehabil* 2005;86:746–54.

18 Katz DI, Polyak M, Coughlan D *et al*. Natural history of recovery from brain injury after prolonged disorders of consciousness: outcome of patients admitted to inpatient rehabilitation with 1–4 year follow-up. *Prog Brain Res* 2009;177:73–88.

19 Fins JJ, Schiff ND, Foley KM. Late recovery from the minimally conscious state: ethical and policy implications. *Neurology* 2007;68:304–7.

20 Wijdicks EF. Minimally conscious state vs. persistent vegetative state: the case of Terry (Wallis) vs. the case of Terri (Schiavo). *Mayo Clin Proc* 2006 Sep;81:1155–8.

21 Voss HU, Uluc AM, Dyke JP *et al.* Possible axonal regrowth in late recovery from the minimally conscious state. *J Clin Invest* 2006;115:2005.

22 Shiel A, Wilson B, McLellan DL *et al. WHIM. Wessex Head Injury Matrix - Manual.* London: Harcourt Assessment, 2000.

23 *Practice parameters: Assessment and management of patients in the persistent vegetative state.* St Paul: American Academy of Neurology: Quality Standards Subcommittee; 1994 [cited 2011 26.11.11]. Available from: www.aan.com/Guidelines/Home/GetGuidelineContent/83 (accessed 4 November 2013).

24 Royal College of Physicians. *The permanent vegetative state.* London: RCP, 1996.

25 Gill-Thwaites H. Lotteries, loopholes and luck: misdiagnosis in the vegetative state patient. *Brain Inj* 2006 Dec;20:1321–8.

26 Majerus S, Bruno MA, Schnakers C *et al.* The problem of aphasia in the assessment of consciousness in brain-damaged patients. *Progr Brain Res* 2009;177:49–61.

27 Childs NL, Mercer WN, Childs HW. Accuracy of diagnosis of persistent vegetative state. *Neurology* 1993 Aug;43:1465–7.

28 Shiel A, Horn SA, Wilson BA *et al.* The Wessex Head Injury Matrix (WHIM) main scale: a preliminary report on a scale to assess and monitor patient recovery after severe head injury. *Clin Rehabil* 1 April 2000;14:408–16.

29 Andrews K, Murphy L, Munday R *et al.* Misdiagnosis of the vegetative state: retrospective study in a rehabilitation unit. *BMJ* 1996 Jul 6;313:13–6.

30 Schnakers C, Vanhaudenhuyse A, Giacino J *et al.* Diagnostic accuracy of the vegetative and minimally conscious state: clinical consensus versus standardized neurobehavioral assessment. *BMC Neurol* 2009;9:35.

31 Giacino JT, Kezmarsky MA, DeLuca J *et al.* Monitoring rate of recovery to predict outcome in minimally responsive patients. *Arch Phys Med Rehabil* 1991;72:897–901.

32 Wilson CF, Graham LE, Watson T. Vegetative and minimally conscious states: serial assessment approaches in diagnosis and management. *Neuropsychol Rehabil* 2005;15:431–41.

33 Seel RT, Sherer M, Whyte J *et al.* Assessment scales for disorders of consciousness: evidence-based recommendations for clinical practice and research. *Arch Phys Med Rehabil* 2010;91:1795–813.

34 Giacino JT, Kalmar K, Whyte J. The JFK Coma Recovery Scale-Revised: measurement characteristics and diagnostic utility. *Arch Phys Med Rehabil* 2004;85:2020–9.

35 Wilson FC, Elder V, McCrudden E *et al.* Analysis of Wessex Head Injury Matrix (WHIM) scores in consecutive vegetative and minimally conscious state patients. *Neuropsychol Rehabil* 2009;19:754–60.

36 Gill-Thwaites H. The Sensory Modality Assessment Rehabilitation Technique – a tool for assessment and treatment of patients with severe brain injury in a vegetative state. *Brain Inj* 1997 Oct;11:723–34.

37 Gill-Thwaites H, Munday R. The Sensory Modality Assessment and Rehabilitation Technique (SMART): a valid and reliable assessment for vegetative state and minimally conscious state patients. *Brain Inj* 2004;18:1255–69.

38 Ansell B, Keenan J. The Western Neuro Sensory Stimulation Profile: A tool for assessing slow-to-recover head-injured patients. *Arch Phys Med Rehabil* 1989;70:104–8.

39 Rader MA, Ellis DW. The Sensory Stimulation Assessment Measure (SSAM): a tool for early evaluation of severely brain-injured patients. *Brain Inj* 1994 May–Jun;8:309–21.

40 Pape TL, Heinemann AW, Kelly JP *et al.* A measure of neurobehavioral functioning after coma. Part I: Theory, reliability, and validity of Disorders of Consciousness Scale. *J Rehabil Res Dev* 2005 Jan–Feb;42:1–17.

41 Delargy M, McCann A, Haughey F *et al.* Review of Prolonged Disorder Of Consciousness (PDOC) Rehabilitation Service provision: A questionnaire survey of UK BSRM members. Dublin: The PDOC Working Group, National Rehabilitation Hospital, 2013.

42 Godbolt AK, Stenson S, Winberg M *et al.* Disorders of consciousness: preliminary data supports added value of extended behavioural assessment. *Brain Inj* 2012;26:188–93.

43 Coleman MR, Davis M, H, Rodd JM *et al.* Towards the routine use of brain imaging to aid the clinical diagnosis of disorders of consciousness. *Brain* 2009 Sep;132:2541–52.

44 Laureys S, Giacino JT, Schiff ND *et al.* How should functional imaging of patients with disorders of consciousness contribute to their clinical rehabilitation needs? *Curr Opin Neurol* 2006;19:520–7.

45 Owen AM, Coleman MR, Menon DK *et al.* Residual auditory function in persistent vegetative state: a combined PET and fMRI study. *Neuropsychol Rehabil* 2005;15:290–306.

46 Fernandez-Espejo D, Bekinschtein T, Monti MM *et al.* Diffusion weighted imaging distinguishes the vegetative state from the minimally conscious state. *Neuroimage* 2010;54:103–12.

47 Coleman M. Personal communication, 2011.

48 Landsness E, Bruno MA, Noirhomme Q *et al.* Electrophysiological correlates of behavioural changes in vigilance in vegetative state and minimally conscious state. *Brain: J Neurol* 2011 Aug;134:2222–32.

49 Oliveira L, Fregni F. Pharmacological and electrical stimulation in chronic disorders of consciousness: new insights and future directions. *Brain Inj* 2011;25:315–27.

50 Meyer MJ, Megyesi J, Meythaler J *et al.* Acute management of acquired brain injury Part III: an evidence-based review of interventions used to promote arousal from coma. *Brain Inj* 2010;24:722–9.

51 DeMarchi R, Bansal V, Hung A *et al.* Review of awakening agents. *Can J Neurol Sci* 2005 Feb;32:4–17.

52 Lombardi F, Taricco M, De Tanti A *et al.* Sensory stimulation for brain injured individuals in coma or vegetative state. *Cochrane Database Syst Rev* 2004;(2).

53 Clauss RP, Guldenpfennig WM, Nel HW *et al.* Extraordinary arousal from semi-comatose state on zolpidem. A case report. *S Afr Med J* 2000 Jan;90:68–72.

54 Clauss RP, van der Merwe CE, Nel HW. Arousal from a semi-comatose state on zolpidem. *S Afr Med J* 2001 Oct;91:788–9.

55 Whyte J, Myers R. Incidence of clinically significant responses to zolpidem among patients with disorders of consciousness: a preliminary placebo controlled trial. *Am J Phys Med Rehabil* 2009;88:410–8.

56 Whyte J, Hart T, Schuster K *et al.* Effects of methylphenidate on attentional function after traumatic brain injury. A randomized, placebo-controlled trial. *Am J Phys Med Rehabil* 1997 Nov–Dec;76:440–50.

57 Martin RT, Whyte J. The effects of methylphenidate on command following and yes/no communication in persons with severe disorders of consciousness: a meta-analysis of n-of-1 studies. *Am J Phys Med Rehabil* 2007 Aug;86:613–20.

58 Whyte J, Katz D, Long D *et al.* Predictors of outcome in prolonged posttraumatic disorders of consciousness and assessment of medication effects: A multicenter study. *Arch phys med rehabil* 2005 Mar;86:453–62.

59 Whyte J, Giacino J. Effectiveness of amantadine hydrochloride for treatment of severe traumatic brain injury (TBI). *ClinicalTrials.gov* 2010.

60 McMahon MA, Vargus-Adams JN, Michaud LJ *et al.* Effects of amantadine in children with impaired consciousness caused by acquired brain injury: a pilot study. *Am J Phys Med Rehabil* 2009 Jul;88:525–32.

61 Giacino JT, Whyte J, Bagiella E *et al.* Placebo-controlled trial of amantadine for severe traumatic brain injury. *N Engl J Med* 2012 Mar 1;366:819–26.

62 Kanno T, Morita I, Yamaguchi S *et al.* Dorsal column stimulation in persistent vegetative state. *Neuromodulation* 2009 Jan;12:33–8.

63 Piccione F, Cavinato M, Manganotti P *et al.* Behavioral and neurophysiological effects of repetitive transcranial magnetic stimulation on the minimally conscious state: a case study. *Neurorehabil Neural Repair* 2011 Jan;25:98–102.

64 Glannon W. Neurostimulation and the minimally conscious state. *Bioethics* 2008;22:337–45.

65 Elliott L, Walker L. Rehabilitation interventions for vegetative and minimally conscious patients. *Neuropsychol Rehabil* 2005;15:480–93.

66 Doman G, Wilkinson R, Dimancescu MD *et al.* The effects of intense multi-sensory stimulation on coma arousal and recovery. *Neuropsychol Rehabil* 1993;3:203–12.

67 Wood R. Critical analysis of the concept of sensory stimulation for patients in vegetative states. *Brain Inj* 1991;4:401–10.

68 Wood RL, Winkowski TB, Miller JL *et al.* Evaluating sensory regulation as a method to improve awareness in patients with altered states of consciousness: a pilot study. *Brain Inj* 1992 Sep–Oct;6:411–8.

69 Boly M, Faymonville ME, Schnakers C *et al.* Perception of pain in the minimally conscious state with PET activation: an observational study. *Lancet Neurol* 2008 Nov;7:1013–20.

70 Schnakers C, Chatelle C, Vanhaudenhuyse A *et al.* The Nociception Coma Scale: a new tool to assess nociception in disorders of consciousness. *Pain* 2010 Feb;148:215–9.

71 Jackson D, Horn S, Kersten P *et al*. Development of a pictorial scale of pain intensity for patients with communication impairments: initial validation in a general population. *Clin Med* 2006 Nov–Dec;6:580–5.

72 Abbey J, Piller N, De Bellis A *et al*. The Abbey Pain Scale: A one minute indicator for people with end stage dementia. *Int J Pall Nurs* 2004;10:6–13.

73 Warden V, Hurley AC, Volicer L. Development and psychometric evaluation of the Pain Assessment in Advanced Dementia (PAINAD) scale. *J Am Med Dir Assoc* 2003 Jan–Feb;4:9–15.

74 Royal College of Physicians. *Use of antidepressant medical in adults undergoing recovery and rehabilitation following acquired brain injury: National guidelines*. London: Royal College of Physicians (London) in collaboration with the British Society of Rehabilitation Medicine, 2005.

75 Turner-Stokes L, Kalmus M, Hirani D *et al*. The Depression Intensity Scale Circles (DISCs): Initial evaluation of a simple assessment tool for depression in the context of brain injury. *J Neurol Neurosurg Psychiatr* 2005;76:1273–8.

76 Hammond MF, O'Keeffe ST, Barer DH. Development and validation of a brief observer-rated screening scale for depression in elderly medical patients. *Age Ageing* 2000;29:511–5.

77 Groswasser Z, Sazbon L. Outcome in 134 patients with prolonged posttraumatic unawareness. Part 2: Functional outcome of 72 patients recovering consciousness. *J Neurosurg* 1990 Jan;72:81–4.

78 National Institute of Health and Care Excellence. *Head injury: assessment, investigation and early management of head injury in children and adults*. London: NICE, National Collaboration Centre for Acute Conditions, 2002.

79 Regional Trauma Networks National Clinical Advisory Group. London: Department of Health, 2010.

80 Royal College of Physicians. *Medical rehabilitation in 2011 and beyond*. London: RCP, 2011.

81 The National Service Framework for Long Term Conditions. London: Department of Health, 2005.

82 Turner-Stokes L, Ward CD. *BSRM Standards for Rehabilitation Services, mapped on to the National Service Framework for long-term conditions*. London: British Society of Rehabilitation Medicine, 2009.

83 British Society of Rehabilitation Medicine. *Specialist neuro-rehabilitation services: providing for patients with complex rehabilitation needs*. London: BSRM, 2010.

84 British Society of Rehabilitation Medicine. *Specialist nursing home care for people with complex neurological disability: guidance to best practice*. London: BSRM, 2012.

85 British Society of Rehabilitation Medicine. *Specialist rehabilitation in the trauma pathway: BSRM core standards*. London: BSRM, 2013.

86 Kitzinger J, Kitzinger C. The 'window of opportunity' for death after severe brain injury: Family experiences. *Sociol Health Illness* 2013;35:1095–1112.

87 Royal College of Physicians. *Oral feeding difficulties and dilemmas: A guide to practical care, particularly towards the end of life*. London: RCP, 2010.

88 The Mental Capacity Act. London: HMSO, 2005.

89 Department of Health. *Reference guide to consent for examination or treatment*. London: DH, 2009.

90 Menon DK, Chatfield DA. *The Mental Capacity Act 2005: Guidance for critical care*. London: Intensive Care Society, 2011.

91 Boly M, Faymonville M-E, Peigneux P *et al*. Cerebral processing of auditory and noxious stimuli in severely brain injured patients: differences between VS and MCS. *Neuropsychol Rehabil* 2005;15:283–9.

92 Laureys S, Boly M. What is it like to be vegetative or minimally conscious? *Curr Opin Neurol* 2007;20:609–13.

93 Schnakers C, Zasler ND. Pain assessment and management in disorders of consciousness. *Curr Opin Neurol* 2007;20:620–6.

94 Bekinschtein T, Leiguarda R, Armony J *et al*. Emotion processing in the minimally conscious state.[Erratum appears in *J Neurol Neurosurg Psychiatry*. 2004 Jul;75(7)1086]. *J Neurol Neurosurg Psychiatry* 2004;75:788.

95 General Medical Council. *Treatment and care towards the end of life: good practice in decision making*. London: GMC, 2010.

96 Johnson LSM. The right to die in the minimally conscious state. *J Med Ethics* 2010;37:175–8.

97 Kuehlmeyer K, Domenico Borasio G, Jox R. How family caregivers' medical and moral assumptions influence decision making for patients in the vegetative state: a qualitative interview study. *J Med Ethics* 2012;38:332–7.

98 Steinbrook RL, Lo B. Artificial feeding – solid ground, not a slippery slope. *New Engl J Med* 1983;318:286–90.

99 NHS End of Life Care Programme. *Advance care planning: a guide for health and social care staff.* London: Department of Health, 2007.

100 Crawford S, Beaumont JG. Psychological needs of patients in low awareness states, their families, and health professionals. *Neuropsychol Rehabil* 2005;15:548–55.

101 Decisions relating to cardiopulmonary resuscitation: A joint statement from the British Medical Association, the Resuscitation Council (UK) and the Royal College of Nursing. London, 2007.

102 Geocadin RG, Koenig MA, Jia X *et al.* Management of brain injury after resuscitation from cardiac arrest. *Neurol Clin* 2008 May;26:487–506, ix.

103 Sandroni C, Nolan J, Cavallaro F *et al.* In-hospital cardiac arrest: incidence, prognosis and possible measures to improve survival. *Intensive Care Med* 2007 Feb;33:237–45.

104 Nichol G, Stiell IG, Hebert P *et al.* What is the quality of life for survivors of cardiac arrest? A prospective study. *Acad Emerg Med* 1999 Feb;6:95–102.

105 The Liverpool Care Pathway 2009: Available from: www.liv.ac.uk/mcpcil/liverpool-care-pathway/documentation-lcp/ [accessed 28 October 2013].

106 Turner-Stokes L, Sykes N, Silber E *et al.* From diagnosis to death: Exploring the interface between neurology, rehabilitation and palliative care, in the management of people with long term neurological conditions. *Clin Med* 2007;7:129–36.

107 George R, Regnard C. Lethal drugs or dangerous prescribers? *Pall Med* 2007;21:1–4.

108 Carter DC. *Review of commissioning arrangements for specialised services.* The Warner report. London: Department of Health, 2006.

109 National Definition Set for Specialised Services No 7: 'Complex specialised rehabilitation for brain injury and complex disability (Adult)', 3rd edn. London: Department of Health, 2009.

110 Health and Social Care Act. London: Stationery Office, 2012. www.legislation.gov.uk/ukpga/2012/7/pdfs/ukpga_20120007_en.pdf [accessed 14 October 2013].

111 Long Term Neurological Conditions Dataset. Leeds, UK: Information Centre for Health and Social Care, 2010.

112 Turner-Stokes L, Sutch S, Dredge R. Healthcare tariffs for specialist inpatient neurorehabilitation services: Rationale and development of a UK casemix and costing methodology. *Clin Rehabil* 2011;26:264–79.

113 Baker A, Potter J, Young K *et al. Grading systems and critical appraisal tools. A study of their usefulness to specialist medical societies.* London: Royal College of Physicians, 2010.